MW00467159

Dear
Sisters

Dear Sisters

A Womanist Practice of Hospitality

▼△▼△▼△▼△▼△▼△▼△▼△

N. Lynne Westfield

THE
PILGRIM
PRESS
Cleveland

Acknowledgment is gratefully given for permission to quote from the following:

"Still I Rise" by Maya Angelou, from *And Still I Rise* by Maya Angelou. Copyright © 1978 by Maya Angelou. Used by permission of Random House, Inc.

"Harriet" and "A Litany for Survival," from *The Black Unicorn* by Audre Lorde. Copyright © 1978 by Audre Lorde. Used by permission of W. W. Norton & Company, Inc.

"We Wear the Mask" from *The Complete Poems of Paul Laurence Dunbar.* Copyright © 1980. Used by permission of Hakim's Publications.

"Bringing Ourselves Home," from *In a Blaze of Glory* by Emilie Townes. Copyright © 1995. Used by permission of Abingdon Press.

Sisters of the Yam by bell hooks. Copyright © 1993. Used by permission of South End Press.

Reaching Out by Henri Nouwen. Copyright © 1975 by Henri J. M. Nouwen. Used by permission of Doubleday, a division of Random House, Inc.

The Pilgrim Press, 700 Prospect Avenue East
Cleveland, Ohio 44115-1100, U.S.A.
www.pilgrimpress.com

© 2001 by N. Lynne Westfield

All rights reserved. Published 2001

Printed in the United States of America on acid-free paper

Library of Congress Cataloging-in-Publication Data
Westfield, N. Lynne.
 Dear sisters : a womanist practice of hospitality / N. Lynne Westfield.
 p. cm.
 Includes index.
 ISBN 0-8298-1449-3
 1. African American women – Social conditions. 2. African American women – Social life and customs. 3. African American women – Religious life. 4. Hospitality – United States. 5. Resilience (Personality trait) – United States. 6. Spirituality – United States. 7. Womanist theology – United States. 8. Christian education – United States. I. Title.

E185.86 .W43864 2001
305.48′896073 – dc21

2001041421

Contents

Preface

Religious education, particularly education in the local church, would benefit greatly from a refocus based on a sacramental understanding of hospitality as modeled by concealed gatherings of Christian, African American women. My experience of that kind of hospitality began as I sat at my mother's kitchen table, which has always been a place of abundant nourishment for my body, mind, and spirit. The table often overflowed with such delicacies as barbecue, collard greens, black-eyed peas, string beans, macaroni and cheese, and yams. Of equal importance, at my mother's kitchen table I would hear, and when old enough I would participate in, conversations, debates, sparrings, and banters concerning everything from religion to politics, with the mundane routines of Black life in America thrown in the middle of the flying, swirling words.

My memories of family gatherings around the kitchen table are particularly vivid around holidays and holy days. The meals provided a place for deep conversations and sharing. Often at the end of a meal, the men would leave the table in search of a ball game on TV. The women would be left to clean up the kitchen and to have wild and wonderful concealed conversations. The women's conversations, arguments, and dialogues taught me what was important, the value of thinking quickly, and the necessity of a Black woman being able to hold her own in discourse. These conversations, lively displays of intellect and keen wit, set for me an expectation of discourse that I carried into the academy and the local church classroom.

Once I entered the classroom—as learner, then teacher—

I found few experiences similar to that of the banter by the women in concealed gatherings. Most classrooms were too often uninteresting, slow paced, even dull. I began to forget about the wisdom and humor of the kitchen table banter until, as a scholar, I began to ask myself how African American women stay resilient. In the journey of this inquiry about resilience, I rediscovered what I already knew—hospitality at the kitchen table with African American, Christian women involved lively discourse, critical thinking, and a great deal of fun. I now know that these gatherings are acts of resistance by sisters who come in search of hospitality and healing. African American women, through conversation in concealed gatherings, engage the agenda of liberation and oppression in ways that are ancient and new. From my experience as a learner, teacher, and researcher and from my own Black woman's imagination, I believe that resilient, Christian, African American women participate routinely in practices that heal and renew, individually and communally. One of the major practices for resilience, and the focus of this book, is the practice of hospitality. Christian, African American women often participate in a stranger-to-stranger hospitality that is practiced in concealed gatherings as one way of revealing and experiencing the sacramentality of life. The hospitality of these gatherings provides a model for a theological and pedagogical refocusing of religious education.

This project belongs to the family, friends, and other travelers who have journeyed with me over many years. As usual, my parents, Lloyd and Nancy, were my staunch supporters. I would not have come this far had it not been for their faith in God and me. They prayed me through, and for that I thank them.

This project originated as my doctoral dissertation, and I am grateful to my committee members. Bob O'Gorman, mentor since graduate school, assisted me in my confusion, and his wisdom grounded me when I needed it most. Elizabeth Minnich gifted me in astounding ways when she invited me

to be her thinking partner. Her influence has coaxed me to write from the truest voice I have found thus far. Chuck Foster, having journeyed with me since my master's program, continues to teach me how to fine-tune my thinking, how to write like I live in community, and how to see my unorthodoxy as a blessing. Lucille Ijoy raved about my poetry when I had not yet named myself as poet. Her ravings showered me with courage. My peers, Pearl Maxwell and Jane Rich, were always responsive and always cooperative. Judith Arcana and Margo Okazawa-Rey, my second readers, provided stimulating feedback that strengthened my program. At the beginning of my doctoral program, I asked one of the Union Institute faculty to tell me what the bottom line was for selecting committee members. There seemed to be too many unforeseeable variables, and the decision was a weighty one. He told me the bottom line was to "pick people who love you." Thank you, committee members, for loving me.

I am in debt to my Dear Sisters' Literary Group. Throughout the program, they have provided me with grace and wisdom. The meetings were always needed fun on a Friday night. They have shown me, reminded me, and schooled me in their own way what hospitality is all about. I thank the women who graciously agreed to be interviewed: Donna Jones, Wilhelmina J. Young, Sharon R. Taylor, Sherry Jones, Carlotta Fareira, Anne Williams, Connye Brown, Cheryl McFadden, Ruth Joseph, Zenobia Gray, Gladys Davis, Delores Marshall, Carole Wright, Barbara Byrd, Brenda Hutter-Simms, and Jane Andrews. I thank them for being coresearchers on this journey. Individually and collectively, I thank you all.

Throughout this project, friends have encouraged, prayed, fed, massaged, and serenaded me. They have kept me laughing, cooked for me, listened to my poetry, and continually healed me. Thank you, my friends: Michele Case, Brother Reginald Crenshaw, Batami Sadan, Harold "Edaki" Smith, Ruth Joseph, Zenobia Gray, Tanya Bennett, and Art Pressley. Thank you to my companion and hound dog Willow—who

lay under my desk on my feet during the years I spent at the computer and who insisted I walk with her in the woods each day, lest I lose touch. And of course, to all my guides, angels, saints, ancestors, spirits, and hants who stopped by, some who stayed, I thank you.

The ancestors say that it takes a village to raise a child. I have been surrounded by a loving, nurturing, challenging, expectant village—and I am grateful beyond measure. To God be the glory!

▼▲▼ 1 ▼▲▼

The Resilience of African American Women

Since before I can remember, strong, capable, fiercely faithful, African American, Christian women have surrounded me. They were, in their own right, Womanists. They are the reason, in large part, that I write as a Womanist religious educator. The term "Womanist" was coined from Alice Walker's use of the folk term "womanish" to characterize the spirit and posture of African American women who, individually and collectively, dare to resist oppression. Alice Walker, author of *In Search of Our Mothers' Gardens,* gives this definition of a Womanist:

1. From womanish (Opp. of "girlish," i.e., frivolous, irresponsible, not serious.). A black feminist or feminist of color. From the black folk expression of mothers to female children, "You acting womanish," i.e. like a woman. Usually referring to outrageous, audacious, courageous, or willful behavior. Wanting to know more and in greater depth than is considered "good" for one. Interested in grown-up doings. Acting grown up. Being grown up. Interchangeable with another black folk expression: "You trying to be grown." Responsible. In charge. Serious. 2. Also: A woman who loves other women, sexually

1

and/or nonsexually. Appreciates and prefers women's cul-
ture, women's emotional flexibility (values tears as natural
counter-balance of laughter) and women's strength. Some-
times loves individual men, sexually and/or nonsexually.
Committed to survival and wholeness of entire people,
male and female. Not a separatist, except periodically for
health. Traditionally universalist, as in: "Mama, why are
we brown, pink, and yellow, and our cousins are white,
beige, and black?" Ans.: "Well, you know the colored race
is just like a flower garden, with every color flower repre-
sented." Traditionally capable, as in: "Mama, I'm walking
to Canada and I'm taking you and a bunch of other slaves
with me." Reply: "It wouldn't be the first time." 3. Loves
music. Loves dance. Loves struggle. Loves the Folk. Loves
herself. Regardless. 4. Womanist is to feminist as purple to
lavender.[1]

Womanist religious education, a burgeoning discipline by
Black female scholars of religion, addresses the pedagogical,
epistemological, spiritual, and sociopolitical implications of
the "tridimensional phenomenon of race, class, and gender
oppression in the experience of African-American women."[2]
Like Womanist theology, Womanist religious education is
committed "both to reason and to the validity of female
imagery and metaphorical language in the construction of
theological [and pedagogical] statements."[3] Womanist reli-
gious education, akin to Womanist theology, is committed to
a "life of the mind" along with full regard for expressions of
the body and soul. Womanist religious education, recognizing
the complexity of African American women's diaspora, makes
use of multidisciplinary and interdisciplinary approaches for
teaching and learning.

1. Alice Walker, *In Search of Our Mothers' Gardens: Womanist Prose* (San
Diego: Harcourt Brace Jovanovich, 1983), xi.
2. Katie Geneva Cannon, "The Emergence of Black Feminist Consciousness,"
in *Feminist Interpretation of the Bible*, ed. Letty Russell (Philadelphia: Westminster
Press, 1985), 39.
3. Delores S. Williams, "Womanist Theology: Black Women's Voices," *Christian-
ity and Crisis*, March 2, 1987, 69.

Gathering as a Source of Resilience

I set out to study spiritual practices of Christian, African American women in the face of persistent oppression.[4] I suspected, and the gap in the literature confirmed, that too many of the religious and spiritual practices of African American women have all but been ignored by scholarship. My hunch was that resilient, Christian, African American women participate routinely in practices that heal and renew individually and communally.

My research began with the simple question, "What is it that keeps African American women resilient?"[5] I did a series of preliminary, in-depth interviews with fifteen women focused upon this question. From the interviews, I identified five practices that these women mentioned and described in the interviews as contributing to their resilience. The five practices are: gathering, pleasuring, playing, praying, and learning. A committee member advised that I select one practice on which to focus. I picked *gathering*.

Using participant observation as my methodology, I worked with a group of women who gathered as a literary group once a week. During this year of observation, I did bibliographic research concerning the notion of "gathering." In the course of these twelve months, I seized upon (or was seized by) the notion of *hospitality* as a foundational practice of resilience for African American women. I then drew on my own imagination and experience as an African American woman immersed in cultures of African American women to argue that Christian, African American women often practice stranger-to-stranger

4. I am indebted to scholars bell hooks, Jacquelyn Grant, Kelly Brown Douglas, Delores S. Williams, Katie Cannon, Marcia Riggs, Emilie Townes, Renita Weems, Clarise Martin, Cheryl Townsend Gilkes, Toinette M. Eugene, Shawn Copeland, and Karen Baker-Fletcher for the descriptions and depictions of oppression that preceded and were interspersed throughout their analyses. Their work, along with the prose and poetry of creative writers (and my own experience), assisted me with language for my project.

5. I have limited the scope of my writing to African American, Christian women. I look forward to a dialogue with many other persons concerning the comparisons and contrasting of my observations with other groups, populations, and times.

hospitality in concealed gatherings as one way of revealing and experiencing the sacramentality of life.

Black Women's Poetic Voice

Along my journey, I was taken with the sheer beauty of the women I met and spoke with about their religious experiences. As we spoke, I could hear the poetry of their experience bubbling forth during our conversations. During and after our conversations, I had numerous moments of revelation, insight, and learning. The women in the study nurtured and released my imagination. My attempt to capture the essential aesthetic of African American women is found throughout this writing in the form of poetry and poetic prose. My poetry, found woven throughout the document, has a logic and springs from quotes, vocabulary, and experiences of the women. Prose quotes from the women I interviewed and observed also appear throughout. By recounting their quotes in prose and poetry, I am taking the words of the women and placing them in a different and new conceptual role in the world. The words can now be used to educate and enlighten many more people.

I chose to write in poetic prose and poetry because the learning, as a result of the research and my "ah-ha" experiences, was profound. I wanted to do more than report the data and research findings I collected. As an artist, I felt compelled to take all that I had seen, felt, learned, relearned, remembered, thought, and experienced from and with the women of the research (and the women of my life), and in some way create a work that represented the power of our bodies, minds, and souls to be and to become resilient. My imagination yearned to honor the expression of resilience that I witnessed in the years of research. At the same time, I understand that this writing project must engage the rigors of scholarship, which need not mean conforming to a prescribed and formulaic approach. To this end, this book draws upon

and is informed by the voices of the women in the study, bibliographic research, participant observation, and a great deal of my own imagination and experience.

In My Own Poetic Voice

My mode of writing and reasoning is a reflective narrative with other voices interwoven: "Womanist epistemology also affirms the use of personal narrative in order to relate black women's history and religious experience."[6] As a Womanist, I lean heavily upon personal narrative to describe the experiences of the women I researched. Rebecca S. Chopp calls this writing style "narrativity." Dr. Chopp says, "Narrativity identifies the felt experience of women as a description of the process of both their lives and their theological educations. For women, and perhaps also for men, the need to write new lives is not a luxury but, as Audre Lorde says of poetry, 'a vital necessity of women's existence.' The power to write one's life as an active agent is the power to participate, potentially and actually, in the determination of cultural and institutional conditions."[7]

The emphasis upon the Bible grows directly from my experience of the language of the women of the study as well as from my own cultural immersion as a Black woman in Black women's culture. My style is narrative in a poetic genre which emerges from a community deeply rooted in the language, imagery, and rhythms of the King James Version of the Bible.

In short, I came to the women, I thought with and listened to the women. My imagination led me to creating a reflec-

6. JoAnne Marie Terrell, *Power in the Blood?* (Maryknoll, N.Y.: Orbis Books, 1998), 8. In chapter 2 of her book entitled *Saving Work: Feminist Practices of Theological Education* (Louisville, Ky.: Westminster John Knox Press, 1995), Rebecca S. Chopp writes concerning the power and utmost importance of women writing in the first-person, reflective mode as a gesture of integrity, scholarship, and affirmation to the uniquely female voice and perspective.

7. Chopp, *Saving Work,* 21.

tive narrative that leans heavily upon the aesthetic mode and aesthetic conceptualizations, which is what I will focus on as I prepare also to discuss implications of my research for religious education.[8]

Definitions

At the outset it seems important for me to discuss key terms that I will be using, which will further clarify the approach that I am taking.

African American Women

The term "African American women" is used throughout this work. I am not using this term, "African American women," as an essentialist term, i.e., I am not talking about "the essence" of African American women. I am not using it as an empirical term either. I have not surveyed all African American women, nor have I surveyed enough to generalize. My use is not intended to be essentialist nor empirical; instead, I invite you to think along with me as I employ the term in the evocative sense. I am using this term as a part of common parlance, but also as it connects with a sociological and historical identity. Occasionally in the writing, I will be specific and identify the voices of the women with adjectives like "Christian" and "activist." At other times in the writing, the language will blur and move away from specificity. I want you to understand that I also identify with the term "African American woman" in this book. I learned what it means from others and shared in those meanings, but I do not wish to impose them on others.

"Resilience" vs. "Survival"

Too often scholars and preachers have talked about the spirit of African American women as possessing the virtues of

8. See Elliot Eisner, *Learning and Teaching the Ways of Knowing* (Chicago: National Society for the Study of Education, 1985).

"survival." Survival is not a virtue, but a result of a base response instinct to environmental conditions. For me, survival presupposes and connotes competition, aloneness, and estrangement. In survival, I see staying, hunkering down, rudimentary maintenance, the struggle to meet necessities. The nuances of survival come from the color of the gray palette—covering the spectrum only from hollowness and waiting to needing and just barely enough. Survival is like a location without juxtaposition or proximity. Survival is like being a "crouched rabbit under a hedge to escape the hounds or like people taking shelter in a cellar to avoid bombs."[9] There is a feeling of only temporary, momentary relief from the pressing, life-controlling dilemma. The courage and faith of many African American women comes from a force far more powerful than the sheer, carnal will of survival. The courage and faith of African American women comes, in part, from the ancient and artful practices of resilience.

Resilience, a better term to describe spiritual tenacity, depicts the spirit I see with, for, and among Christian, African American women. Unlike survival, resilience connotes a more communal sense of being and belonging. In resilience there is "moving out/moving on," living, self-actualization, a growing together, a sense of ripeness, thriving, an experience of "go!" Resilience is like a room with many thresholds; a room with windows that open wide to vistas and views and that bring in fresh air. Resilience is where choice and location unfold into horizons, new dawns, rich possibilities. For oppressed, African American women, resilience is about finding ways of living within one's context and understanding the context so well that one reconstitutes the self while in chaos (but not out of chaos) to see one's self in a positive light while the world around would say the opposite. Resilience is the feeling of security, protection, and stability emerging from the

9. Thich Nhat Hanh, *The Heart of Understanding* (Berkeley, Calif.: Parallax Press, 1988), 4.

midst of risk. Resilience is like a baby whose head and neck are held securely. Resilience is about mastering the terrain of the oppressive context so well that one re-creates and heals the self in the very midst of chaos. It is mastering the ability to see one's self in a life-affirming light while the world around would shroud her in shadow. This process takes a lifetime, performed generationally from woman to woman and women to women. *Lafiya* is a Nigerian term meaning, "I am well, I am whole." Developing the practices of resilience allows African American women to respond to the question, Do you want to be healed? not from the perspective of the dehumanization of oppression, but from ancient and sacred wisdom: God's intent is that "I am well, I am whole."

Practices of the Ordinary

Elizabeth Dodson Gray, editor of *Sacred Dimensions of Women's Experience* (1988), brought to voice a longtime experience of African American women and our practices of resilience, our doing of theology within our lives, our living. Dr. Gray wrote that "women name the sacred differently than men name the sacred."[10] Too many male scholars have been trained, trained themselves and others, to take private, intimate ideas and experiences of their own lives and convolute them into supposedly universal truths. Gray describes how, when she first read Paul Tillich's *The Courage to Be,* she was disconcerted that Tillich never described any of his personal grappling with the notion of courage.[11] Yet, in the absence of personal disclosure, he spoke with great authority proclaiming "truth." Tillich, like too many of the other recognized, legitimatized theologians, disconnected his personal experience from scholarship; disconnected his heart from his brains; disconnected a faith journey from the task of teaching, and

10. Elizabeth Dodson Gray, ed., *Sacred Dimensions of Women's Experience,* (Wellesley, Mass.: Roundtable Press, 1988), 17.
11. Ibid.

confused what may be true for him with universal truth. This is not the way I want to do pedagogy or theology, nor is it the way that the women in my experience practice their faith. For us, experiences of God reside in the mystery between our own examined lives and a horizon that surpasses any individual or group's meanings, a mystery we enter through the practices of the ordinary, not through abstract theorizing about which most of us are ignorant.

Therefore, this writing project is grounded in the particularity of the subjective events of faithful, Christian, African American women who both have and strive for resilience. It is about women who experience and name the sacred out of their ordinariness. We meet the sacred with our senses and sensuousness, brailling God with our bodies, minds, and spirits: "Our naming of the sacred is thus life-affirming rather than life-separating or life-distancing."[12] We submerge ourselves in the ordinariness of life simply and profoundly because that is where God meets us and has met us for generations. When I was a child I would watch and listen as my maternal grandmother would clean and dust her house and sing. The more she sang, the more she would dust. Invariably, during the dusting and the singing she would pray, shout, "get happy," and "have church" all over the house. I used to think my grandmother was a little peculiar; now I understand that she was deeply engaged in life, in God, in becoming and remaining resilient.

This book, then, is an exploration that led me to a description of the practices of hospitality by Christian, African American women for African American women as a constitutive element of resilience. Poetry and prose are woven together in an effort to convey as well as portray, to express as well as analyze and describe, cultural and gender nuances of a particular kind of hospitality, which I call "stranger-to-stranger" hospitality. This work is also an attempt to honor "kitchen table

12. Ibid., 15.

poets." Paule Marsha' novelist, said in a TV interview, "Language is the only homeland." The poets of the kitchen I honor are those African American, Christian women who have, in the spinning of tales and the crafting of language, defied death and carved out a splendid living. The use of poetry and poetic prose, an artist's expression of exploration, is chosen because of the profound complexity of African American women. The artistic expression allows description without dissection, exploration without violation, interpretation without devaluation or redaction.

With this background, consider the original, huge, and unanswerable question that gave rise to this project:

WHAT IS IT?

What is it?
sheer grit muscle iron will
uncompromising
steely stone hard-assed bitchy attitude?

What is it?
faith in good times & bad
discipline reflexibility
knowing when to hold 'em when to run?

Is it just plain dumb luck
day to day unexpected
unplannable
cherished upon surprised arrival?

The will of God?—
a god who would spare
some taunt
others?

Maybe it is simply momentum
gravity inertia
dynamics of a spherical planet
in an edgeless cosmos?

What is it?
that keeps a Black woman's head UN-bowed
back UN-broken
spirit IN-tact?

What is it?
that keeps her
fresh alive
vibrant still?

Maybe Who? Who is it?

Her children fulfilled
promise of age long past
love of her life
quenched yearning of her soul?

Her mother revered misunderstood?
grandmother who taught her
to pray I lift up mine eyes upon the hills
taught her to smile graciously when angry?

her sisters
brothers husbands
lovers bosses best friend
pastor priest her imam?

Who is it? or What is it?
that enables
dance without benefit of orchestra
flight with just one wing
full voluptuous laughter
 deep down belly deep laughter
 side splitting
 show-every-tooth-in-her-head laughter?

that powers her
to charge forward

to take charge
to be in charge
 to lead
 doing more with less than seemingly possible
 making fancy garments from plain threads
 creating banquets from crumbs
 building warm nests even in the midst of icy
 poverty?

it must be something
not of this world
something which bubbles
forth from Mystery
given at conception
reenforced at birth
refined honed along life's way
melded tested each & every day
it must be large
delicate
timelessly changing
& eternal

What is it? or Who is it?
that allows her
to wake up & get up
triumph with dignity & pa-zazz?
What? or who? ever that is
I want it
What is it?
that allows
black women to be BLACK WOMEN?

⩗ 2 ⩗

Gathering the Voices

My students at Drew Theological Seminary, Madison, New Jersey, insist upon asking me the "how" question. They want to know "how" to make theories in the classroom applicable to the local church setting and to their own lives as pastors. The men and women ask, in many ways, "how" is seminary preparing them to live out their call and responsibility for ministry. My students, even when I attempt to dissuade them or delay my response, insist on posing the "how" question in hopes of revealing strategy, snaring a glimpse to hidden process, enabling them to duplicate routines.

My caution for engaging the "how" question comes from a conversation I had years ago with an elder scholar, Dr. Ernie Smith, former president of Rust College. Dr. Smith said, in effect, that the who, what, when, where, and why questions are engageable, even answerable—but the "how" question is the hardest of all to satisfy. The "how" question changes from era to era, location to location, even from person to person.

How "it" works for me is not how "it" works for someone else. How "it" worked in the 1950s is not necessarily how "it" works in the twenty-first century. How I researched and conceptualized this book is not "how" others effectively research and write. Still, my students bombard me with the "how" question, demonstrating its importance in the discourse. Their yearning for "how did it happen; how should

13

it happen; how to make it happen?" is a major consideration and a critical question.

Researching and writing this book were wondrously organic learning experiences for me. Like many scholars and artists, I ended up in a place much different than I had anticipated. This chapter is a description of "how" my thinking began, then shifted, changed, rearranged, and resettled. I describe "how" I gathered up the voices of scholars and poets in order to teach myself to listen to and for the voices of my sisters.

bell hooks: My Point of Departure

The work of bell hooks, especially *Sisters of the Yam* (1993), illuminated my understanding of African American women's need for and ability for healing and resilience. Dr. hooks writes:

> Having lived in a segregated southern black world and in an integrated world, where black people live with and among whites, the difference I see is that in the traditional world of black folk experience, there was (and remains in some places and certainly in many hearts) a profound unshaken belief in the spiritual power of black people to transform our world and live with integrity and oneness despite oppressive social realities. In that world, black folks collectively believed in "higher powers," knew that forces stronger than the will and intellect of humankind shaped and determined our existence, the way we lived. And for that reason these black people learned and shared the secrets of healing. They knew how to live well and long despite adversity (the evils caused by racism, sexism, and class exploitation), pain, hardship, unrelenting poverty, and the ongoing reality of loss. They knew joy, that feeling that comes from using one's powers to the fullest. Despite the sexism of that segregated black world, the world of spirituality and magic was one where black women teachers, preachers, and healers worked with as much skill, power,

and second sight as their black male comrades. Raised in such an environment, I was able to witness and learn.[1]

Although hooks talks extensively about the need for African American women to cultivate a communal nature, to gather and pull together, to nurture self for the support of others, she does not name a coherent set of phenomena that can, I believe, be found in the community for those purposes. The naming and description of these phenomena were my major interest. Hooks's book *Sisters of the Yam* did, however, set me upon the quest to see the phenomena that have kept many African American women resilient.

Religious Womanists

My original question was neither radical nor complicated. I simply asked, "What enables many African American women to wake up and get up?" I was able to find religious literature that spoke to the notion of "survival" by Black women. Religious Womanist scholars like Katie Cannon, Emilie Townes, Delores Williams, and Cheryl Townsend Gilkes write poignantly about the plight and survival of African American women in terms of race, class, and gender issues. For example, Dr. Cannon writes, "From the period of urbanization of World War II to the present, Black women find that their situation is still a situation of struggle, a struggle to survive collectively and individually against the continuing harsh historical realities and pervasive adversities in today's world."[2] And Dr. Townes writes,

> Womanist wisdom springs out of wives, partners, aunts, grandmothers, mothers, other mothers, comrades, worshipers, protesters, wisdom bearers, murderers, and saints in African American culture and society—and in the life of the church. This perspective—which flows from surviving,

1. bell hooks, *Sisters of the Yam* (Boston: South End Press, 1993), 8–9.
2. Katie Cannon, *Katie's Canon* (New York: Continuum, 1995), 55.

as women, in a society based on inequalities rather than
justice—is one that yearns for glory. Such glory is found in
seeking a new heaven and new earth—a world crafted on
justice and love that holds us all in God's creation rather
than in a hierarchy of oppressions.[3]

Dr. Williams writes, "For the African-American woman,
the wilderness experience—a sojourn in the wide world to
find survival resources for self and children—has often in-
volved mourning the death of her children. The end has not
been caused by starvation. Rather, it has been caused by the
systematic effort of the State and some of its white support-
ers to discourage black progress by a form of destruction
African Americans are today labeling genocide."[4] Dr. Gilkes
says the womanist concept "lays out very clear positions
that Black women ought to adopt based upon the best tra-
ditions ingrained in their legacy of struggle, survival, and the
construction of African-American women's culture."[5] These
scholars echo and expound upon the brilliant work of James
Cone, author of *For My People:*

> When we consider slavery, lynching, ghettoes, and Ronald
> Reagan's vicious attack upon the rights of the poor, how
> can we explain blacks' mental and physical survival? How
> was it possible for black slaves to hope for freedom when
> a mere empirical analysis of their situation of servitude
> would elicit despair? How is it possible for blacks today
> to keep their sanity in the struggle for freedom when they
> consider the continued exploitation of the poor in a world
> of plenty? I belong to a Christian community whose mem-
> bers believe that we blacks have come "this far by faith,"
> leaning on the God of our slave grandparents. We have

3. Emilie Townes, *In a Blaze of Glory* (Nashville: Abingdon Press, 1995), 10.
4. Delores Williams, *Sisters in the Wilderness* (Maryknoll, N.Y.: Orbis Books,
1993), 130–31.
5. Cheryl Townsend Gilkes, "The 'Loves' and 'Troubles' of African-American
Women's Bodies: The Womanist Challenge to Cultural Humiliation and Commu-
nity Ambivalence," in *A Troubling in My Soul: Womanist Perspectives on Evil and
Suffering,* ed. Emilie M. Townes (Maryknoll, N.Y.: Orbis Books, 1993), 237.

survived slaveships, auction blocks, and chronic unemployment because the God of black faith has bestowed upon us an identity that cannot be destroyed by white oppressors. It is the knowledge that we belong only to God that enables black Christians to keep on fighting for justice even though the odds might be against us. We firmly believe that Jesus heals wounded spirits and broken hearts. No matter what trials and tribulations blacks encounter, we refuse to let despair define our humanity. We simply believe that "God can make a way out of no way." Black Christians do not deny that trouble is present in their lives; we merely insist that "trouble does not last always" and that "we'll understand it better by and by."[6]

The notion of "survival" obviously permeates the literature of religious African American scholars, but I wanted to work with a notion related to survival, but different from survival. I wanted to work instead with the notion of "resilience." And though I can hear resonances of "resilience" in the writings quoted, they are talking about survival as the base subsistence of living for African American women. These scholars do, however, use the voices of ordinary women to speak about survival. As Dr. Cannon asserts, "The Black woman's collection of moral counsel is implicitly passed on and received from the one generation of Black women to the next. Black females are taught what is to be endured and how to endure the harsh, cruel, inhumane exigencies of life."[7] Each of the women I have cited makes reference, at some point in her texts, to "ordinary" women as women of substance and triumph. A prime example of this is found in the foundational definition of "womanist" used by all these scholars as it was coined by Alice Walker.[8] In her four-pronged definition, Walker states the following dialogue as capturing essences of Womanist perspective:

6. James H. Cone, *For My People* (Maryknoll, N.Y.: Orbis Books, 1984), 206–7.
7. Katie Cannon, *Black Womanist Ethics* (Atlanta: Scholars Press, 1988), 4.
8. Alice Walker, *In Search of Our Mothers' Gardens: Womanist Prose* (San Diego: Harcourt Brace Jovanovich, 1983), xi.

"Mama, I'm walking to Canada and I'm taking you and a
bunch of other slaves with me." Reply: "It wouldn't be the
first time."

Walker's statement is of ordinary women preparing to do,
and remembering having done, extraordinary things. An-
other example is found in Delores S. Williams's *Sisters in the
Wilderness:*

> By ordinary, I mean those black women who are not in the
> limelight like Harriet Tubman, Sojourner Truth and Mary
> McLeod Bethune. Ordinary black women are day-workers,
> factory workers, teachers, etc. (usually church women) who
> do their bit day by day contributing to black women's way
> of resisting and rising above the brutalities in the society
> that oppress black women and their children, male and
> female.[9]

Dr. Katie Cannon, pioneer of Womanist ethics, wrote her
dissertation to show "how Black women live out a moral
wisdom in their real-lived context that does not appeal to the
fixed rules or absolute principles of the white-oriented, male
structured society."[10] An emphasis on scholarship which turns
to lived experience of African American, Christian women is
where I wanted to locate my work. James Cone says it this
way: "Black women, by giving an account of their faith in
worship and living out their faith in the world, create the
context for authentic theological reflection."[11]

With focus on "ordinary" women and their authentic, lived
experience, Womanist scholars like Walker, Williams, Can-
non, Townes, and Gilkes are eminently helpful in analyzing
both the plight and the hard-won triumphs that we experi-
ence as an oppressed race and gender. However, one of the
primary foci of religious Womanist scholarship is to shape

9. Williams, *Sisters in the Wilderness,* 241.
10. Cannon, *Black Womanist Ethics,* 4.
11. Cone, *For My People,* 135–36.

and reshape "the" intellectual paradigm of religious fields in attempts to "map out survival strategies."[12] This recasting of "the paradigm" presumes accurately that the dominant voices are White men and the controlling structure is racist, sexist, classist, and heterosexist. However, this recasting by religious Womanist intellectuals in some ways has the unintended affect of positioning their work toward a reactive rather than an open posture. It fixes their gaze too much on what has been done by dominant scholarship and not enough on people and groups whose scholarship has been excluded and devalued. These scholars are so close to the dominant scholarship (perhaps this is understandable given the fact that they must make a living in these all-boy clubs if they are to be intellectuals at all) that too much time is spent comparing, contrasting, and reacting to dominant structures and prescribed realities rather than freely excavating, creating, or conjuring representative paradigms for and with African American women.

The redefinition or re-creation of scholarship to represent muffled and stifled African American women's voices is most evident to me in these scholars' extensive employment of autobiographies, speeches, novels, testimonies, songs, oral histories, sermons, and poetry. Though they often speak of artistic renderings as wellsprings of African American women's religious experience (much work has been done, for example, on the works of Zora Neale Hurston, Toni Morrison, and Alice Walker, to name a few) few scholars have attempted to convey their own ideas in a "more-than-intellectual" art form. Few Christian scholars have made the artistic process part-and-parcel of their scholarly methodology.

Dr. Emilie M. Townes's work *In a Blaze of Glory* is an exception to this critique. In this work, she offers several original poems as gateways into her analytical prose. "Bringing Ourselves Home" is one of my favorites:

12. Katie Cannon, *Katie's Canon* (New York: Continuum, 1995), 25.

you can
always
tell
when old black
women
go to church
'cause they
smell so good
and after
they been
your
way
the heavy odor
lingers in
the air
and you
smile
'cause
one
day
you hope
you
can be
an
old
black
woman
too[13]

Dr. Townes writes in her introduction:

In my attempt to put to paper a spirituality that is lived, I
sorted through these possibilities [work of poetic writers]
for an entry point. In utter frustration, I turned to my own
poetic voice to break the silence. Poetry came as a response

13. Townes, *In a Blaze of Glory*, 120.

to a sermon found in Toni Morrison's novel *Beloved.* The way had revealed itself! As I searched through other novels and consulted with friends, a methodology emerged that seemed true to the experience of Black women's spirituality and moved into a womanist mode of seeking to push beyond what is the ordinary or the norm in Black life, to explore the possibilities.[14]

Dr. Townes has begun to develop a methodology that begins with the aesthetic, moves to analysis, then gives consideration to socioethical issues for reshaping the community. I could see and sense the power of her methodology to communicate, to persuade, and to represent in vivid ways previously unrepresented voices.

From Survival to Resilience

So, I depart from the survivalistic philosophy of Religious Womanists and invest myself in notions of resilience. My central question was related to, but slightly different from, the questions that I heard these Religious Womanists asking and addressing. I wanted to know of the women "who do their bit day by day contributing to black women's way of resisting and rising above"—*what are those ways?* I not only wanted to say that ordinary women are important, which Williams, Cannon, and Townes certainly say, but I wanted to study, observe, and describe their practices of ordinariness, particularly those practices by women who have demonstrated an achievement of resilience.

While striking similarities exist between my work and that of other religious Womanists, my work is predicated upon listening to and living with the "here and now" voices of African American women rather than any prefounded judgment of the import of our voices. Thus, while I cite Emilie Townes and Katie Cannon and depend upon their scholar-

14. Ibid., 11.

ship, I find that our foci diverge at important points between
the essence of survival and resilience. Additionally, I wanted
to shape my work using the aesthetic as means of scholarship
as well as using the aesthetic as the subject of scholarship.
I wanted to shape my work to be about ordinary African
American women, but I also did not want my work con-
veyed through the mainstream male voice that the scholarly
guilds employ for communication. I understand that art, in
and of itself, is an act of resistance, an act of humanness,
an act of freedom born out of liberative activity, as well as
born out of a personal experience of grace. I wanted my
work to embody the voices of the women by capturing the
voices through poetry, not simply reporting upon their voices
as subjects.

Resilience in the Work of Novelists and Poets

I discovered my question and quest deeply embedded in the
wisdom of Alice Walker and other Womanist novelists, poets,
short-story writers, and essayists. Walker, in her book *In
Search of Our Mothers' Gardens,* asks the question, "How
was the creativity of the black woman kept alive, year after
year and century after century, when for most of the years
black people have been in America, it was a punishable
crime for a black person to read or write?"[15] I resonated
strongly with this query and I found that Zora Neale Hurston,
Dorothy West, and Rebecca Jackson engaged it as well. I
also found the question addressed in the novels of Maya
Angelou, Toni Morrison, Paule Marshall, Tina Marie Ansa,
Terri McMillan, Toni Cade Bambara, Paula Giddings, Alice
Childress, and Gloria Wade-Gayles. Poets like Sonia Sanchez,
Maya Angelou, Rita Dove, Audre Lorde, and Gwendolyn
Brooks consider it in their works. Also embedded in the writ-

15. Walker, *In Search of Our Mothers' Gardens,* 234.

ings of these women are vivid descriptions and depictions of how many African American women have honed the art of resilience over the centuries. This excerpt of Maya Angelou's "Still I Rise" gives a flavor of her teaching:

> You may write me down in history
> With your bitter, twisted lies,
> You may trod me in the very dirt
> But still, like dust, I'll rise.
>
> Does my sassiness upset you?
> Why are you beset with gloom?
> 'Cause I walk like I've got oil wells
> Pumping in my living room.
>
> Just like moons and like suns,
> With the certainty of tides,
> Just like hopes springing high,
> Still I'll rise.[16]

My personal favorite of these women's work is "A Litany for Survival" by Audre Lorde:

> And when the sun rises we are afraid
> it might not remain
> when the sun sets we are afraid
> it might not rise in the morning
> when our stomachs are full we are afraid
> of indigestion
> when our stomachs are empty we are afraid
> we may never eat again
> when we are loved we are afraid
> love will never return
> and when we speak we are afraid
> our words will not be heard
> nor welcomed

16. Maya Angelou, *Phenomenal Woman* (New York: Random House, 1994), 7.

but when we are silent
we are still afraid.

So it is better to speak
remembering
we were never meant to survive.[17]

These literary kin embodied the grasp of the unique cultural phenomena of African American women. Their artistry engaged my own poetic voice as I struggled to research, write, and learn.

A Focus on Gathering

After reading about the notion of myths that demoralize Black women—finding Sue K. Jewel's work (1993) very helpful—a conversation with Charles Foster brought up the following question: In the face of the hegemonic experience of dehumanization, what kind of rituals exorcize the pain, and embody both resilience and hope for many African American women?

This question provided the foundation for my first round of interviews. From this question and the preliminary interviews emerged an essay that focused on gatherings of African American women as powerful rituals and change agents for healing. This essay—a milestone in my thinking as I moved, without yet realizing it, toward the notion of hospitality—I built upon the thinking of Lesley Northup (1993), Morton Kelsey (1974), W. E. B. DuBois (1903), Nathan Mitchell (1993), and Scott Peck (1978). After some chiding by Charles Foster, I read Paul Tillich (1963) and Rollo May (1969).

In the essay I stated:

The everydayness of African-American women's lives is the acting out of myth. It is the attempt to make meaning out of the patterns of images with which one has been

17. Audre Lorde, *The Black Unicorn* (New York: W. W. Norton, 1978), 31–32.

acculturated, albeit, acculturated in an experience of de-
humanization by a White, racist society. Morton Kelsey,
author of *Myth, History, and Faith*, describes myth as a
pattern of images with important meanings. Myth is the
idea or symbol of the reality and its meaning. Kelsey says
that myth which is not acted out in some way is almost
incomplete. Kelsey writes that myth is both spoken or writ-
ten patterns of images, but most importantly, myth can be
lived.[18]

I go on to say in the article:

Gathering together is a basic act of humanness. "While the
rituals themselves may vary enormously—in intensity and
duration, in social significance and cultural origin, in com-
munal meaning and personal adherence—their presence
marks our relationships as distinctively human."[19]

By suggesting a mythic dimension of gathering, the article
helped me to begin to think through the importance of
gathering for many African American women.

I found all of the work to be interesting, but at the same
time I found myself reacting negatively to the stilted prose and
ungrounded (though not unfounded) theories. I kept asking
myself "so what?"—"what do these theories have to say to
the lives of the women I want to talk with?" In what ways can
we spring out of conventional scholarship into a Womanist
framework that sounds, feels, smells, tastes, and looks like
Black women?

While reading these authors, I conducted more interviews
with African American women. I began to hear deeply the
contemporary voices of African American women focusing
upon issues concerning practices of resilience. As I did the
interviews, I began to hear patterns in their responses that

18. The text consulted for the quote in my essay was: Morton T. Kelsey, *Myth, History, and Faith* (New York: Paulist Press, 1974).
19. Quote in this article was taken from: Nathan Mitchell, "Mystery and Manners," *Worship* 67 (March 1993): 164–73.

pointed toward the joy and complexity of African American women simply in the ritual of gathering. Until this time I knew that hearing African American voices was important, but when I considered their voices over against reading the above authors, there was no comparison. It was like eating a meal versus reading a cookbook. All of the above authors were helpful, but what I was looking for were the voices of real women talking about their own lives. Hear, now, three of the voices:

Carlotta Fareira

[There is] a great sense of freedom, and I can tell you that I traveled around a bit after I retired and I would always seem to be in a group of white people and I was very sorry that I couldn't find a person of color to travel with me. I knew it would be better because things that I said to them (the white people) were just surface things and there were many things that I would have shared with a Black person (had a Black person been traveling with me). (1996)

Delores Marshall

It's just a sisterhood there and it's a warm feeling. We know that we can talk about anything. We can say anything. We can talk about our husbands. We're joking about them. But it's a love there that we are talking about. But it's an understanding that we have our own kind of vocabulary. And we have our own kind of understanding. Whereas if there were someone else in there, it would be cold. We wouldn't (talk openly or freely). We have a good time at our meetings. (1996)

Sherry Jones

It's fun and there are times that we can sit and say things that you don't have to have an explanation because you've been there. It's that thing that we know we deal with—sexism and racism—in our lives. (1996)

Mysticism and Spiritualism

My focus now turned exclusively to the notion of gathering as a tool for resilience. Attending Womanist conferences and conferences of African American sexuality helped to narrow my understanding of "gatherings." These conferences helped me to see that these gatherings, as an activity of African American women, were not in and of themselves climates that fostered resilience. During this time in my study and research, my own spiritual practices began to blossom. I was taking classes in Therapeutic Touch, Reiki, receiving weekly massages, doing past-life regressions, and learning to play the didjeridoo. I resonated with Michael Harner, who suggests in his book *The Way of the Shaman* that one reason people are returning to the ancient practices "is that many educated, thinking people have left the Age of Faith behind them. They no longer trust ecclesiastical dogma and authority to provide them with adequate evidence of the realms of the spirit."[20]

I was intrigued by the work of Carlos Castaneda, who wrote that sorcery is "the act of embodying some specialized theoretical and practical premises about the nature and role of perception in molding the universe around us."[21] I saw myself in the words and work of Luisah Teish, author of *Jambalaya*. She taught me that

we have learned the true definitions of words, which have, in the past, been shrouded in fear and perverted by misinterpretation. Words such as *witch* have been redefined in the light of their true origin and nature. Instead of the evil, dried-out, old prude of patriarchal lore, we know the witch to be a strong, proud woman, wise in the ways of natural medicine. We know her as a self-confident freedom fighter, defending her right to her own sexuality, and her right to govern her life and community according to the laws of

20. Michael Harner, *The Way of the Shaman* (San Francisco: HarperCollins Publishers, 1990), xi.
21. Carlos Castaneda, *The Art of Dreaming* (New York: HarperPerennial, 1993), vii.

nature. We know that she was slandered, oppressed, and burned alive for her wisdom and her defiance of patriarchal rule.[22]

Joan Borysendo, author of *The Power of the Mind to Heal* (1994), called imagination, matters of the heart, and mystery principles of healing. She went on in her book to talk about the art and practices of healing through meditation, dream work, and forgiveness. Caroline Myss, author of *Anatomy of the Spirit* (1996), framed and reframed the ancient notion of *chakras* for contemporary healing practices. I was also profoundly inspired by the work of John Fox, author of *Poetic Medicine:*

> Poetry is a natural medicine; it is like a homeopathic tincture derived from the stuff of life itself—*your experience*. Poems distill experience into the essentials. Our personal experiences touch the common ground we share with others. The exciting part of this process is that poetry used in this healing way helps people integrate the disparate, even fragmented parts of their life. Poetic essences of sound, metaphor, image, feeling and rhythm act as remedies that can elegantly strengthen our whole system—physical, mental and spiritual.[23]

These readings and experiences immersed me in mystical practices (some Christian and some not), and healing as an everyday spiritual practice. These authors pointed the way for me to incorporate the importance of intimacy, touch, body, energy, and prayer in thinking about the healing power of gatherings. I began exploring the idea of "embodiment of resilience" and asked what practices of spirituality, both mystical and ordinary, women engage in for resilience. In my exuberance with my new question and new adventures, I shared these "unorthodox" experiences with friends and colleagues. My sharing was met with doubt, suspicion, and

22. Luisah Teish, *Jambalaya* (San Francisco: HarperCollins, 1985), ix.
23. John Fox, *Poetic Medicine* (New York: Jeremy P. Tarcher/Putnam, 1997), 3.

superstition. Many of my friends chided me about doing "voodoo" and becoming a "witch."

I learned quickly where the lines of spiritual taboo were drawn for many Christian, African American women and how not to cross them, at least in public. I abandoned the language I was learning from Castaneda, Myss, and Harner simply because it stopped rather than enhanced the conversations with many African American women. I did not abandon those underlying concepts of embodiment that I resonated with and which I heard many African American women struggling to name and describe in the interviews and observations. From these readings and practical experiences I became intensely aware of the disconnectedness of body, mind, and spirit and the absolute necessity to reconnect.

White Women Scholars

Around this time I began to put the notion of "gatherings" together with the individual and communal need for intimacy and connectedness. For this conversation I returned to my friend Maria Harris (1991). In Dance of the Spirit, Dr. Harris devised a very helpful template. She wrote about a concrete set of verbs that were not only practices, but virtues of spiritual awakening and healing. Harris employs the use of poetry and suggests practices to readers for their own journey. One of the strengths of Dr. Harris's work is that she writes out of her own self-understanding. She writes as a White woman. As a White woman scholar she has many similarities to what I heard Black women saying, but many differences were also apparent. I was attempting to write with equal integrity out of my own self understanding. I wanted to write as a Black woman representing the unique characteristics of Black women. Think of Irish clogging: While being similar to tap dancing, the music is different and the dances are very different at important places.

For example, Harris defines the seven steps toward spiritual

awakening and healing as being (1) Awakening, (2) Dis-
Covering, (3) Creating, (4) Dwelling, (5) Nourishing, (6) Tra-
ditioning, and (7) Transforming. She suggests that a person
must complete step one before going to step two and step
two before going to three, and so on. This is like clogging—
everyone doing the same thing at the same time. For tap
dancing in the African American jazz tradition, the gratifi-
cation of mastering the tap is when the dancer can improvise.
The spirituality of the African American woman yearns for a
personal style. To confine her to the seven steps is to ask her
to learn to clog rather than tap.

I had a similar experience with the work of Elizabeth
Dodson Gray, editor of *Sacred Dimensions of Women's Expe-
rience* (1988). Gray, along with several other women, wrote
about the sacred as experienced by women. Their book talks
about seven dimensions of sacredness as experienced by and
expressed by women: (1) Women's Creativity, (2) Giving
Birth, (3) Caregiving, (4) Creating Sacred Space, (5) Doing
Housework, (6) Feeding as Sacred Ritual, and (7) Our Bodies
as Sacred. In setting this book apart from other, masculine,
objective scholarship, Gray said, "These writings are rooted
in the particular. They are clothed in the subjective. They are
luminous with the sights, sound, and feel of a real individual
woman's life."[24] Gray went on to say, "Women's renaming
of the sacred is quite different (from men). Our style is to
peer into the richly woven texture of ordinary human experi-
ence and to find already woven there a golden strand of what
we would name sacred. Instead of distancing ourselves and
withdrawing from the reality of life to find sacredness, we go
toward that reality—toward bodies, toward nature, toward
food, toward dust, toward transitory moments in relation-
ships. And wherever we look, we find that which nourishes
and deepens us."[25]

24. Elizabeth Gray, *Sacred Dimensions of Women's Experience* (Wellesley, Mass.:
Roundtable Press, 1988), 1.
25. Ibid., 2.

Gray's use of the term "dimensions" helped me to see that spiritual practices are not only activities of the body, mind, and spirit, but are dimensions of the manifestation of the sacred within each woman's life. Gray helped me to see the narrowness of masculinized scholarship in which "objectivity" is used as an excuse for spiritual shallowness. Gray's poetic writing style helped me to name what I knew intuitively: that is, what the Black women were talking about when they spoke of gatherings, intimacy, and healing. Informed by Gray's understanding of women naming the sacred in the ordinariness of life, I was able to name the experience of many African American women—an experience I was trying to articulate as "hospitality."

Black women and White women have similar experiences. The works of Harris and Gray were very helpful in articulating this concept. But White women and African American women also have vastly different experiences—if for no other reason than we name our race in conversations. In the introduction of the book, Dr. Gray writes several paragraphs describing the women writers in the book. She says, "We are as wondrously diverse as the many colors in (a) medieval tapestry." Dr. Gray then goes on to describe their ages, religious affiliation, vocations and occupations, educational background, and marital status. She finally says, "One of us is black, one is Dutch, all of us are Western (although one of our scholars is steeped in the life and art of India, another in the life and art of northeast Brazil)."[26] Never in the text does she name herself as White nor does she name the other writers who are White. Black women do not have this luxury or privilege. My work focuses upon the experiences of African American women, and if White women can connect with what I find, we will have grounds for further work. But if not, my trajectory will not have changed.

I am not undertaking a project that attempts to compare

26. Ibid., 4–5.

and contrast African American women and White women.
If a future dialogue of comparison is to be fruitful, African
American women must be fully present to ourselves first. The
work of Harris and Gray, in its clarity of focus and integrity to
gender, renewed my courage to write as an African American
woman for and with African American women.

Concealed Gatherings

Honey, Hush! by Daryl Cumber Dance (1998) records Afri-
can American women's spiritual phenomena as it is lived out
in our humor. Stylistically, this anthology of African Ameri-
can women's humor is contemporary, rhythmic, illuminating,
and evocative. Dance weaves several genres together using
poetry, prose, jokes, and riddles. She even wrote a disclaimer
for scholars who would question her legitimacy for having
not quoted and footnoted Jung, Freud, and Fanon (certainly
a kindred spirit). Dance writes,

> The material in this book is the natural delight of my life,
> what I grew up with, what created bonds of friendship for
> me, what I read whenever I get a chance, what helps me
> through the night, what I want to pass on to others. I see no
> need to summon Jung and Freud or even Fanon to discuss it
> (though I may occasionally drop their names here or there
> to make a few of my academic friends happy). I loved it just
> as much before I ever heard those names as I do now. All
> you linguists, theorists, psychoanalysts, structuralists, de-
> constructionists, feminists, womanists, black aestheticians,
> and Marxists are welcome to do what you want with this
> material, but as for me, I'm going to just plain have some
> good laughs and a healthy massage as I enjoy it anew with
> you, my new friends.[27]

In her introduction, Dance names what I had heard and
experienced all through my research, all through my life, but

27. Daryl Cumber Dance, ed., *Honey, Hush!* (New York: W. W. Norton,
1998), xxxv.

was unable to name. She describes occasions when women would come together around a table in the kitchen, without men or White people, and laugh. Dance calls these events "concealed gatherings," a term that conveys precisely what I had been struggling to name. Dance's focus in this text is strictly upon laughter and humor. As she says, "If there is any one thing that has brought African American women whole through the horrors of the middle passage, slavery, Jim Crow, Aunt Jemima, the welfare system, integration, the O. J. Simpson trial, and Newt Gingrich, it is our humor."[28] Laughter and humor are constitutive elements of hospitality at concealed gatherings.

Focus on Education

As a Christian religious educator, my hope and prayer is ultimately to affect African American women through Christian education. Many scholars have informed and illuminated my learning about hospitality and the classroom. Certainly Paulo Freire, with his critique of the "banking system" of adult education and his construct of critical consciousness, is enlightening. Freire says, "Education is suffering from narration sickness. The teacher talks about reality as if it were motionless, static, compartmentalized, and predictable.... In the banking concept of education, knowledge is a gift bestowed by those who consider themselves knowledgeable upon those whom they consider to know nothing."[29] For Freire, "Liberation is a praxis: the action and reflection of men (sic) upon their world in order to transform it."[30] bell hooks says about Freire, "Freire has had to remind readers that he never spoke of conscientization as an end itself, but always as it is joined by meaningful praxis."[31]

28. Ibid., xxi.
29. Paulo Freire, *Pedagogy of the Oppressed* (New York: Continuum, 1981), 57, 58.
30. Ibid., 66.
31. bell hooks, *Teaching to Transgress* (New York: Routledge, 1994), 47.

I am mindful that Freire does not mention "gathering" as part of his construct of freedom. However, for Freire freedom is not a gift, not a self-achievement, but a mutual process. Gathering—that is to say, African American women coming together away from the ears and eyes of White folks and without the presence of African American men—and the hospitality offered as an act of resilience in the gathering are acts of freedom, gestures of resistance and hope, and a practice of resilience.

The spiritual dimensions and the sacredness of teaching are present in the words of Parker Palmer, who greatly illuminated my thinking concerning the spiritual nature of teaching, my understanding of the many kinds of gatherings of African American women, and the nature of teaching for and with African American women. Dr. Parker says:

Authentic spirituality wants to open us to truth—whatever truth may be, wherever truth may take us. Such a spirituality does not dictate where we must go, but trusts that any path walked with integrity will take us to a place of knowledge. Such a spirituality encourages us to welcome diversity and conflict, to tolerate ambiguity, and to embrace paradox.[32]

Henri Nouwen alludes to notions of hospitality in many of his writings. In *Reaching Out* (1975), he names hospitality as an alternative to hostility:

In our world full of strangers, estranged from their own past, culture and country, from their neighbors, friends and family, from their deepest self and their God, we witness a painful search for a hospitable place where life can be lived without fear and where community can be found. Although many, we might even say most, strangers in this world become easily the victim of a fearful hostility, it is possible for men and women and obligatory for Christians to offer

32. Parker Palmer, *To Know As We Are Known* (San Francisco: HarperCollins, 1993), xi.

an open and hospitable space where strangers can cast off their strangeness and become our fellow human beings. The movement from hostility is hard and full of difficulties. Our society seems to be increasingly full of fearful, defensive aggressive people anxiously clinging to their property and inclined to look at their surrounding world with suspicion, always expecting an enemy to suddenly appear, intrude and do harm. But still—that is our vocation: to convert the "hostis" into a "hospes," the enemy into a guest and to create the free and fearless space where brotherhood and sisterhood can be formed and fully experienced.[33]

Dr. Nouwen goes on to say about the biblical notion of hospitality:

... [I]f there is any concept worth restoring to its original depth and evocative potential, it is the concept of hospitality. It is one of the richest biblical terms that can deepen and broaden our insight in our relationships to our fellow human beings. Old and New Testament stories not only show how serious our obligation is to welcome the stranger in our home, but they also tell us that guests are carrying precious gifts with them, which they are eager to reveal to a receptive host.[34]

Dr. Nouwen concludes his chapter on hospitality by saying:

To convert hostility into hospitality requires the creation of the friendly empty space where we can reach out to our fellow human beings and invite them to a new relationship. This conversion is an inner event that cannot be manipulated but must develop from within. Just as we cannot force a plant to grow but can take away the weeds and stones which prevent its development, so we cannot force anyone to such a personal and intimate change of heart, but we can offer the space where such a change can take place.[35]

33. Henri J. M. Nouwen, *Reaching Out* (New York: Doubleday, 1975), 65–66.
34. Ibid., 66.
35. Ibid., 76–77.

Nouwen falls short, however, when addressing the notion of racism and the intrinsically racist and misogynistic machine of American society. The closest he comes to speaking about the insidiousness of racism is when he says, "People who are unfamiliar, speak another language, have another color, wear a different type of clothes and live a lifestyle different from ours, make us afraid and even hostile."[36] Dr. Nouwen, though his work is helpful in many ways, never confronts the reality of oppression as social norm, which is apparent in "stranger-to-stranger" hospitality.

Education as the Practice of Freedom

I end this literature quest where I started—with bell hooks. Clearly, Dr. hooks, in dialogue with Thich Nhat Hanh and Paulo Freire, makes the case for the necessity to change the educational system. Dr. hooks writes in *Teaching to Transgress* (1994):

> In his work Thich Nhat Hanh always speaks of the teacher as a healer. Like Freire, his approach to knowledge called on students to be active participants, to link awareness with practice. Whereas Freire was primarily concerned with the mind, Thich Nhat Hanh offered a way of thinking about pedagogy which emphasized wholeness, a union of mind, body, and spirit. His focus on a holistic approach to learning and spiritual practice enabled me to overcome years of socialization that had taught me to believe a classroom was diminished if students and professors regarded one another as "whole" human beings, striving not just for knowledge in books, but knowledge about how to live in the world.[37]

With the notion that mind, body, and spirit, are one, hooks skillfully weaves personal reflection with scholarly prose to describe and analyze the current educational situation.

36. Ibid., 68–69.
37. hooks, *Teaching to Transgress*, 14–15.

hooks's focus is upon critiquing and changing the entire higher education system by redefining education as a "practice of freedom":

> To educate as the practice of freedom is a way of teaching that anyone can learn. That learning process comes easiest to those of us who teach who also believe that there is an aspect of our vocation that is sacred; who believe that our work is not merely to share information but to share in the intellectual and spiritual growth of our students. To teach in a manner that respects and cares for the souls of our students is essential if we are to provide the necessary conditions where learning can most deeply and intimately begin.[38]

The description of the practice of freedom is built from hooks's memories of classroom experiences of her childhood where, in segregated schools, African American teachers taught African American learners much more than the lessons of math, history, and science. In all of the classrooms, a silent and living curriculum with a moral, cultural, and political agenda nurtured freedom—indeed, religious education at its best. Hooks remembers a place and an experience where learning was enjoyable, writing that, "School was the place of ecstasy—pleasure and danger. . . . [T]o be changed by ideas was pure pleasure."[39] hooks theorizes that when Black learners entered desegregation and learned primarily from White teachers, the lessons served to reinforce racist stereotypes and perpetuate oppression. Education was no longer a place of freedom, but a place "that merely strives to reinforce domination."[40]

For hooks, to educate as a practice of freedom is to cultivate a place of excitement, where everyone's presence is genuinely valued, and where the teaching is dynamic, even sacred. hooks ends her book by saying, "The academy is

38. Ibid., 13.
39. Ibid., 67.
40. Ibid., 84.

not paradise. But learning is a place where paradise can be created. The classroom, with all its limitations, remains a location of possibility. In that field of possibility we have the opportunity to labor for freedom, to demand of ourselves and our comrades an openness of mind and heart that allows us to face reality even as we collectively imagine ways to move beyond boundaries, to transgress. This is education as the practice of freedom."[41]

My own study indicates that desegregation ended the concealed gathering that took place in Black education.

Hearing the Voices of African American Women

Along the way, I have listened to the voices of bell hooks, religious Womanists, novelists and poets, mystics and spiritualists, White women, and religious educators. The focus of this journey was to listen to these voices so that I might hear better when I listened for the voices of African American women—both youthful and more seasoned. I wanted to "gather up" the voices so that when I heard the voices of African American women in their lived context, I would hear them clearly. The unmapped road of this journey starts and ends with experience instead of with theories of education or theology.

My goal is not to arrive at my own prescriptive or normative educational strategy. Rather, what I am pursuing is an investigation that will (a) assist African American women, and others who want to join the dialogue, to understand and to appreciate the richness of having mastered the art of resilience, thus demonstrating that oppression does not have the last word; and (b) illumine the commonplace practice of hospitality as a tool of resilience moving toward freedom. That my work is partisan for African American, Christian women

41. Ibid., 207.

merits no apologies. For too long, scholarship and the church have ignored the lives and religious experiences of African American women. One test of this work will be whether African American women who routinely participate in concealed gatherings recognize the practice as one that hones resilience. The second test is whether Womanist scholars looking for pedagogical insight for classes in higher education will find this work helpful. The third test is whether Womanist pastors will begin to redesign educational models for use in the local church that are more resonant with the ways of African American women. If these criteria are met, then this study will have been significant.

▼ 3 ▼

Hospitality among Dear Sisters

The "Dear Sisters' Literary Group" came together in 1995. We met monthly in each other's homes for three to four hours on a Friday night. The women of the group ranged in age from twenty-seven to seventy-two. The idea of the twenty-one-membered group was simple: we would be Christian, African American women reading books primarily authored by African American women. We would come together once a month for a discussion of one of the books. After some preliminary discussion about the future texture of the group, we were clear that we were *not* going to be one of those women's groups that cook elaborate meals and eat at every meeting. We were going to be a "thinking" group. We saw ourselves as a newly forming group of women who were "intellectual" and "astute" and who would enjoy debate, conversation, and discussion.

The first meeting organized in August went smoothly with lots of discussion and fun and with only the serving of sodas and juice. The September meeting was quite the same. The sister who hosted the October meeting apologetically served chips, pretzels, and fruits. Even though she was playfully scolded by the other group members, all snacks were consumed. During the November meeting, a few women thought it might be "good" to have a party atmosphere for the De-

cember meeting. Each woman agreed that a light "snack" to share would be appropriate due to the holidays. I had the pleasure of hosting this pivotal meeting. One by one and two by two the women arrived with smiles on their faces and with arms filled with "snacks" to share. Our first Christmas "snack party" was a feast of ham, potato salad, collard greens, green beans, candied yams, tossed salad, carrot cake, chocolate cake, and peach pie. Since that momentous communion, we are still sharing a meal at each meeting. Each woman brings a pot to share, while the host home prepares the meat. The table is set to overflowing with dishes of varied and wonderful description. We begin chatting upon arrival, catching up with each other and greeting each other, most having not seen any member of the group in a month. Then the host convenes the conversation about the book of the month. After about an hour of conversation the host quietly slips out of the room to unwrap, dish up, warm up, and set out the evening's banquet. The group is called to dinner and all the sisters gather around the table in a circle and prayer is offered. During the eating and praising of the cooks and recipes, discussion turns to current events and local, national, and international news. The rest of the evening, usually another three hours, is spent in eating, laughing, telling stories, and enjoying the company of dear sisters.

The "Dear Sisters" are, of course, real women in a real group: the center of my research. I suggest, however, that they also represent groups who offer one another hospitality in concealed gatherings. Concealed gatherings, away from Whites and African American men, are powerful events for African American women filled with food, laughter, and deadly serious moments of healing, release, and relaxation.[1]

1. The distinctive nature of concealed gatherings of African American women may have overlapping characteristics with other concealed gatherings such as groups of men on golf courses or men who gather in barber shops for conversations or women who gather in spas. I would welcome conversations with persons who would want to compare and contrast these kinds of experiences with the experiences of African American women at kitchen table gatherings. I am aware that many kinds

The gatherings unburden and unencumber women—they lift
spirits and realign body with mind with soul:

UNENCUMBERED SELF
(FOR MY DEAR SISTERS' LITERARY GROUP)

I.

Long struggle
Monthly long
Struggle
Week
Long struggle
Day/Minute/Second/
Anticipation/expectation/oh please . . .

II.

I will arrive
Too often scarcely
hardly/only/just barely/
but/
When I get there
Oh
I will make sure
I get there
If no where else
When I get there
I will sit
In comfortable chair
Close my burning eyes
Raise my tired hands
Rub my eyes
Both of them real hard
I will breathe deeply deeply
Deeply as I sit back

of concealed gatherings exist, but for the purposes of this work I am focused upon
African American women.

I will gaze upon faces
Of my Sistahs
Gathered for same/for sanity/for centuries/
Faces which remind me
What is important
Who is important
Faces which re-instill
What is valued
Above all else
Who is valuable
Faces which reassure me
I can remove
 Lies from my mouth/masks from my face/weapons
 from my hands

III.

Our laughter peels back
Molten tar of days' scorn
That scorched
My tender skin
Laughter dissolves
Chunks of evil
Which otherwise devour me cannibalize me
Laughter erases
Stains of hatred
Spewed upon me meant to torture
In this gathering of Sistahs
Able
To voice truth
Known & forgotten
Truth
Beaten brutalized suffered
In their absence
Able
To laugh at all
That was funny

As well as damnable/intolerable
While sitting/laughing/talking
Smells waft by umm ummm

IV.

Umm smells of care
wellness/hope
Teaching me
She thought enough of me
To cook for me

V.

I leave comfort chair
Help myself to food
Talk ripples/rambles/raucous
Stories wax wane
Halo-ed advice-wisdom
Rolls to aged heaven
I rise & move
Through talk immersed/submerged/absorbed
Letting laughter wash over me/through me/into me
Allowing witty repartee
To mend me
I walk through washing & mending of me
I make my way to table
Communion table
Where cup of blessing/bread of life
Awaits
I help myself
To delicacies
Fried/baked/stewed
With plate heaping full
I eat food
Cooked for me
By her & her & she

copper-browned brilliant Dear Sistah
light-skinned red-boned queenly Dear Sistah
bronzy-browned goddess-like Sistah

Food for my delight
By my Dear Sistah girl

VI.

With food/talk/laughter
will I
will we
Feel me human again
Will I
Will we
Fill my stomach growl
Will I
Will we
Re-align my body
With my soul
With our God

VII.

It is when
We are together
Reunioned
That I am restored
Unmasked/Accepted/Loved
For my faults & my fictions
For my debts & my dedications

VIII.

My Sistahs
Are river
Where I lay my burdens down
Altar Where I cry
For purpose/meaning/blessing
Salve for my wounded bleeding heart

IX.

It is they who
When we are gathered
Remake me
Into my
Unencumbered self
Reshape me into
My most resilient self
They See & know
Me true

Defining Hospitality

In many ways, to describe hospitality is to describe the delightfulness of being human. To be human is to know hospitality. In her bounty and beauty, Mother Nature, our planet Earth, provides hospitality so that we might live. Each human comes into the world after having enjoyed the hospitality of mother's body, of mother's sacred womb. Henri Nouwen, author of *Reaching Out,* defines hospitality this way:

Hospitality... means primarily the creation of a free space where the stranger can enter and become a friend instead of an enemy. Hospitality is not to change people, but to offer them space where change can take place. It is not to bring men and women over to our side, but to offer freedom not disturbed by dividing lines. It is not to lead our neighbor into a corner where there are no alternatives left, but to open a wide spectrum of options for choice and commitment. It is not an educated intimidation with good books, good stories and good works, but the liberation of fearful hearts so that words can find roots and bear ample fruit. It is not a method of making our God and our way into the criteria of happiness, but the opening of an opportunity to others to find their God and their way. The paradox of hospitality is that it wants to create emptiness, not a fearful emptiness, but a friendly emptiness where strangers can

enter and discover themselves as created free; free to sing
their own dances; free also to leave and follow their own
vocations. Hospitality is not a subtle invitation to adopt
the life style of the host, but the gift of a chance for the
guest to find his own.[2]

Yet, hospitality is elusive. Each of us has, at one time or another, been a guest at a party where the host was inattentive, even cold. Too many of us have attended worship services where the congregation, by their scowls and unfriendliness, treated the visitors as unwelcomed guests. All of us, at one time or another, have been in need of hospitality but found none. All of us have experienced dehumanizing estrangement when hospitality was withheld. Precisely the ordinariness and the elusiveness of this experience make it so compelling:

EDAKI'S KITCHEN

On a sunny winter morning
I arrived for a first visit
@ my friend's home. With some hesitancy,
upon her wooden porch
I pushed door bell button &
stepped back to wait. In not long at all
my friend opened her largelarge door
greeted me with arms wide opened
& with a full-lipped smile kissed me,
hugged me, Hello. I entered her home,
she helped me with my coat, cheerfully invited me
into her lovely living room. A blazing fire
awaited me, I warmed myself,
melting my hesitancy into comfort. I stood
in her fire's blue gold glow
taking in her anticipation
preparation of my comfort, my friend invited me

2. Henri J. M. Nouwen, *Reaching Out* (New York: Doubleday, 1975), 71–72.

into the kitchen. As I walked
through her home, into her hospitable kitchen,
I smelled freshly baking cookies, my tender
heart & my empty stomach shyly grinned. My friend
prepared tea, asking my preference
of flavors & honeys. We sat
together @ her kitchen table, slowly
talking, attentively listening, laughing,
nibbling warm cookies, sipping
tea out of oversized purple mugs,
being friends.

Hospitality is a host's friendly sharing of resources for the comfort of a guest. Of equal or greater importance, hospitality is the genuine, uninhibited sharing of self: spontaneous laughter, rest, reassurance, comfort, and familiarity. Hospitality is an attitude. Dr. Nouwen writes: "We cannot change the world by a new plan, project or idea. We cannot even change other people by our convictions, stories, advice and proposals, but we can offer space where people are encouraged to disarm themselves, to lay aside their occupations and preoccupations and to listen with attention and care to the voices speaking in their own center."[3] Hospitality, like that experienced by the Literary Group, has everything to do with being able to exhale, breathe deeply, and talk openly.

In the hospitality of the Literary Group, guest and host both experience a deep sense of welcoming acceptance. Hospitality, as demonstrated in the group setting as well as in one-on-one conversations, is an experience of shared intimacy. Receiving hospitality reminds and reawakens women to love. "Hospitality is one way to take love out of the realm of theory and make it a part of our daily lives."[4] The giv-

3. Ibid., 76.
4. Bruce Rowlinson, *Creative Hospitality* (Campbell, Calif.: Greenleaf Press, 1981), 31.

ing and receiving open and unbind women to experiences of grace. To receive hospitality, women exercise graciousness:

No Shhhhh! Here

there's no
shhhhh!
@ these here gatherings
might be a "Honey Hush!"
or a
"Chile you go 'way from herr'!"
or a
"Stop ya' lyin'!"
but there's no
Shhhhh here.

Scripture reminds us that giving is better than receiving (Acts 20:35). This wisdom points to the nobility of hosting and the difficulty of being a guest. As the guest, the one who submits to receive, one allows the host to do the better: "To engage in the reciprocity of hospitality is to welcome something new, unfamiliar, and unknown into our life-world."[5] Hospitality is powerful because it can provide contexts in which crucial interactions of love, compassion, and empathy—which are means of grace—have a chance to take place.

Constitutive Elements:
Intimacy, Reciprocity, and Safety

The members of the Literary Group, through the giving and receiving of hospitality, experience a welcome that is articulated in their actions. They are especially expressive and conducive of intimacy. The women of the group engage in banterous conversation throughout the evening gatherings.

5. Thomas W. Ogletree, *Hospitality to the Stranger: Dimensions of Moral Understanding* (Philadelphia: Fortress Press, 1985), 76.

How do minorities feel about whites openly talking about them?

Certain assumptions operate in the conversations. The assumptions grow out of the shared intimacy and feeling of safety within the group.

One activity that denotes the feeling of safety is the open talking about White people, whose agenda is woven into the conversation at every gathering. This topic is most evident during the conversations on current events after dinner. The women talk in depth about the racism of the media and the government. The sisters also recount and analyze recent crimes involving African American children and teens, which verify, for the women, that racism is still pervasive and an ever-present threat to their children. The unbridled conversations about racism and "White people" are clear indications of the solidarity and safe climate of the group.

Every gathering also encompasses sharing of prayer and food. At the beginning of the formation of the group I was hesitant about praying before the meals, and when I did pray I was intentional about being inclusive in the prayer. I did not want to offend any non–church member or any non-Christian member. One of the group members (and a consultant to my doctoral dissertation team), Dr. Lucille W. Ijoy, spoke to me gently twice about the need to pray with the group. Finally, when I did not comply, Dr. Ijoy said, "Look, all Black women are praying women—you better pray and stop apologizing and making excuses. We need to pray together and you need to do it with this group." From that time on, prayer has been a welcomed and essential part of the meal time, clearly giving a kind of ritual recognition of intimacy and safety that are assured by sharing faith.

At every gathering, whether as a group or between individual members, some "catching up" takes place. Members check in with each other about jobs, children, church projects, etc.... Every meeting prompts open, lively, and personal comparison of "my real life" and the lives and experiences of the characters in the books the group has read (the overwhelming majority of the books selected are authored by

African American women). At every meeting, too, plans are made to ensure the next meetings. All of these activities indicate a kind of hospitality that affirms trust and vulnerability. These activities are also clues to the nurturing and generous care of African American women by other African American women. This experience of trust is further demonstrated by what does not occur. The women dress casually to attend the meetings, putting no fashion pressure on the group. Little time is spent talking about hair or nails. Time is not spent talking about the women who are not present. Surprisingly, little time is spent talking about the woes and heartaches of African American men. On at least three occasions, women commented on how enjoyable the gatherings were for these reasons. Anne Williams (1996) said:

> I couldn't be bothered with gossipy chatter...that's not what we do together. We enjoy the book, reading it and talking about it. We enjoy each other's company. I laugh a lot when we are together.

Gladys Davis (1996) said:

> I liked reading before, and I was interested in the group. I was afraid that the group would be just another time to gossip and tell tales out of school. But we are not [like that]. We talk about the book, current events—things that really matter.

The Literary Group, in their sharing of giving and receiving by rotating from home to home, demonstrates the importance of reciprocity. Each woman gladly takes a turn hosting the group. One women, Gladys, lives in an apartment too small to host the group. She takes her turn by hosting the group in the home of another member. While visiting in each other's homes, the women spend time "oh-ing & ah-ing" about the host's home. Generous comments are routinely heard concerning artwork and displayed family photos. Occasionally,

a husband will come to make a plate after meal time. The women receive him warmly. I suggested once that the group not rotate from house to house. My suggestion was dismissed with the women saying they enjoyed meeting in different homes and they enjoyed hosting (especially since it was only once a year).

The women read works authored by African American women about African American people because they enjoy hearing their own stories. There is a reciprocity of storytelling, of mutual recognition between reader and author as well as among the readers. The Literary Group believes these books—and by extension their own stories—are valuable, as signaled by the time spent each month reading and dialoguing about the books.

The Experience of Inhospitality

By discussing inhospitality, we can also learn more about the experience of hospitality. The mere association of people is not necessarily a hospitable encounter. Bruce Rowlinson, author of *Creative Hospitality*, observes that hospitality is not simply fellowship. Fellowship, accommodation, or friendliness can be gestures or tools of inhospitality, as well as hospitality. Rowlinson says that encounters of people chatting about "not much of nothing" for the sole purpose of superficiality denote inhospitality. Inhospitable gatherings neither welcome nor share in intimacy between host and guest.[6]

For many African American women, the experience of inhospitality is vivid, even normative. As victims of racism and sexism, we are too often treated like unwelcomed strangers by Black men and by White folk alike. Author bell hooks, in *Sisters of the Yam*, writes that few other public events showed the rift between African American women and White folks

6. Rowlinson, *Creative Hospitality*, 21.

and between African American women and African American men more sharply than the Clarence Thomas Supreme Court nomination hearings.[7] White women sided with Anita Hill, but they naïvely insisted, reports hooks, that their unity was located only in the role of gender, which either had nothing to do with race or transcended race. African American men publicly and privately ridiculed Anita Hill for not "standing by a Brother." hooks says that these hearings are but a small example of the outcast position of African American women in contemporary time. As the title of Barbara Smith's anthology has it, *All the Women Are White, All the Blacks Are Men—but Some of Us Are Brave.*[8]

Not only are African American women treated inhospitably by society at large, the Black church also alienates us.[9] The African American church, historically the stalwart place of hope and liberation, has nevertheless too often disappointed and neglected her people on the issue of hospitality.[10] Painfully, gatherings in many (not all) local churches for African American women are dehumanizing experiences fraught with sexism, prejudice, and climates fostered by misogynistic assumptions and presuppositions. There is prejudice within the pew for one another and prejudice within the pew for pulpits occupied by women. There is prejudice between pulpits as female pastors tear one another down. African American

7. bell hooks, *Sisters of the Yam* (Boston: South End Press, 1993).

8. See Gloria T. Hull, Patricia Bell Scout, and Barbara Smith, eds., *All the Women Are White, All the Blacks Are Men—but Some of Us Are Brave* (Old Westbury, N.Y.: Feminist Press, 1982).

9. See Frances E. Wood, "Take My Yoke Upon You" in *A Troubling in My Soul: Womanist Perspectives on Evil and Suffering,* ed. Emilie M. Townes (Maryknoll, N.Y.: Orbis Books, 1993).

10. For theological attempts to define the Black church, see James Cone, *For My People: Black Theology and the Black Church* (Maryknoll, N.Y.: Orbis Books, 1985); James Deotis Roberts, *Roots of a Black Future: Family and Church* (Philadelphia: Westminster Press, 1980). For a sociological definition of the Black Church, see C. Eric Lincoln and Lawrence Mamiya, *The Black Church in the African American Experience* (Durham, N.C.: Duke University Press, 1991); W. E. B. Du Bois, *The Negro Church* (Atlanta: Atlanta University Press, 1903); E. Franklin Frazier and E. Eric Lincoln, *The Negro Church in America: The Black Church since Frazier* (New York: Schocken Books, 1974).

women, both in the pew and in the pulpit, too often struggle
and neither find nor give hospitality in the church.[11]

The women of the study said they do not expect nor ex-
perience the kind of intimacy in church that they share with
each other in the Literary Group. Of the fifteen participants
interviewed for this project, none mentioned the church as a
place of hospitality. None, including sisters with female pas-
tors or who are female pastors, mentioned the experience at
the communion table as an experience of hospitality. "We
have communion once a month and it's no big deal.... [I]t
makes the sermon shorter...sometimes" (Wright 1996). "In-
timacy in worship...no...that's not what it's for" (Sherry
Jones 1996). "I don't go to church to feel welcome. I go
to worship God....I don't care if the people are petty"
(Davis 1996). Many of the women said that they gather with
other women who are members of their church away from
church and experience hospitality in activities such as literary
groups or dinner clubs. Five of the women commented that
at church the climate was "bitchy" and "backbiting" (Young,
Wright, Joseph, Donna Jones, Williams [all 1996]). "There is
too much backbiting, fighting, and arguing at my church to
call it 'intimacy.'...We don't get along hardly at all" (Tay-
lor 1996). The women said that not only was the church
not supportive, but the groups of the church were openly
competitive and mean-spirited. Several women commented
that wardrobe, fashion, and cliquish attitudes dominated the
groups (Williams, Brown, Marshall [all 1996]). At least four
of the women cited gossip in their congregations as one of
the ways the church is inhospitable (Brown, Jones, Gray,
Young [all 1996]). The experience of inhospitality, whether
in the church or in the world, is an experience that in-
tends to silence women and leaves them to wonder while
fending alone:

11. For further discussion see, James Cone, *For My People* (Maryknoll, N.Y.:
Orbis Books, 1984), chap. 6.

Simile of In-hospitality

This is not like the in-hospitality
when you had planned to go
to the park to run & giggle & play
like a kaleidoscope pointed toward light
but instead
you peep through the curtain
discover rain
 this is not the eternal-momentary
 sadness of a disappointed child

That's not this

This is not like the in-hospitality
of the teenager having been stood-up
on that first date
 face, red swollen
 now buried in cotton pillow
 fist clenched
 dress wrinkled
 beyond salvage, certain love has passed her by

That's not this either

This is more like the estrangement
of a solitary person in a crowd of
plastic faces conversation laced
with pleasantries & cocktails but
names are not forgotten because they
were never remembered

This is like the feeling when
you see Black men cornered:
"Spare change...got any spare change?"
the warrior/chieftain melted to beggar

This is more like the anguish
of voiceless women desperately
drowning in the sobs of hungry children

This is the vulnerability of aproned
woman watching her man go to war
knowing children will one day go
to war like watching & knowing
her children will one day go to war
watching... knowing her children will
go to war (like seed corn to planting)

This is like the horror of dis-covering the Lie

This in-hospitality has jagged tears

ulcerated stomachs bent-over backs
It is without choices
like a room without thresholds
This in-hospitality vomits sanity
leaves insanity as nourishment.
This in-hospitality finds her as stranger
leaves her as stranger
relying upon her never to find home again.

Strangers Portrayed in Song

African American women, oppressed pariahs of this society,
are strangers when we are hosts and we are strangers when we
are guests. We are strangers in every encounter. The notion of
"stranger" as description for the existential reality of African
American women is rooted in the metaphors of the enslaved,
ancestor poets who wrote spirituals:

I'm a poor, wayfaring stranger,
While journeying through this world of woe,
Yet there's no sickness, toil and danger,
In that bright world to which I go;
I'm going there to see my father,
I'm going there no more to roam,
I'm just going over Jordan,
I'm just going over home.

The naming of one's self is a powerful act. "The poet, certainly knowing her own address and place of servitude, named herself a 'stranger.'"[12] Nonetheless, this poet's sad images of estrangement, homelessness, and despair are brightened by the ever present hope of: "I'm just going over home."

The experience of "strangers in a strange land" has not dissipated for African American women in contemporary time. An often sung spiritual during worship in African American churches is "Deep River":

> Deep river,
> My home is over Jordan,
> Deep river, Lord,
> I want to cross over into camp ground.
> Lord, I want to cross over into camp ground,
> Lord, I want to cross over into camp ground,
> Lord, I want to cross over into camp ground.

Richard Newman, author of Go Down, Moses, reminds us that "the 'campground' in the song refers to both Heaven and the free land of the North, and to the homeland of Africa."[13] A haunting sense persists that home is somewhere else with a great divide of separation between. The song's mournful melody, with its onomatopoetic tone, still brings congregations of women to tears. There are few "Women's Days," revivals, or funerals in African American churches where the song "Precious Lord, Take My Hand" by Thomas Andrew Dorsey is not sung. The repeating phrase in this song is "Lead me home," though it's not the title phrase. The poet's genius is evident. African American women, then and now, know home to be somewhere other than where we are—our prayer is to be led home.

12. Richard Newman, Go Down, Moses (New York: Roundtable Press, 1998), 17.

13. Ibid., 54.

The spirituals—whoever wrote them, whoever sings and is moved by them as many are—are also vehicles for expression of the longtime experience for African American women of being a "stranger." African American women, even now, still resonate with metaphors that name our experience as estrangement and the need to go to the familiar place of home. An interviewee expressed just this resonance:

> I feel out of place...unwelcomed in most places like school, my job, sometimes my church, too. I feel like people are watching me thinking I'm going to steal something or break something or mess something up. They don't look at the White women like that. They act glad to see the White women. But me, they turn up their noses like I don't have anything good to offer. (Taylor 1996)

A different woman with a similar experience reported:

> I don't look to be welcomed. My mother always told us we had to take care of our own and whatever we did not have we went without. We soon learned that if we put our little bits together we had plenty. No, I'm used to feeling like an outsider.... [I]t don't bother me no more. (Williams 1996)

A Yearning for Hospitality

Henri Nouwen, in his book *Reaching Out*, describes hospitality by tracing the meaning of the word in many languages. Nouwen cites that in the German language, the word for hospitality is *Gastfreundschaft*, which means "the friendship of the guest."[14] The Greek word, says Nouwen, for hospitality is *philoxenos*, which means "lover of strangers." Hospitality, then, is about friendship and love. For African American women, the irony of these definitions is that neither guest nor host are fully free to befriend the other in a racist, sexist world. Furthermore, neither host nor guest are loved for their true selves perpetually burdened by the distressing expression

14. Henri Nouwen, *Reaching Out* (New York: Bantam Doubleday, 1975), 17.

of oppression. This double bind creates a distinctive feature in the hospitality of African American women.

This stranger-as-guest to stranger-as-host experience of hospitality is not rare, nor recent. Stranger-to-stranger hospitality is one of African American women's responses to torture, brutality, rape, poverty, and hatred. Their response of hospitality is, for Christians, born out of faith in Jesus. Jesus, when asked which commandment is the greatest, responded by telling the people to offer God and one another hospitality. Jesus said we are to love the Lord our God with all our heart, and with all our soul, and with all our mind; and we must love our neighbor as ourself (Matthew 22:35–38). This response of hospitality by many Christian, African American women is an act of faith in Jesus, who commanded that compassion be the human priority.

The stranger-as-guest to stranger-as-host experience of stranger-to-stranger hospitality was first sparked on the long, heinous voyage from homeland through the middle passage. It began when African women took that last glimpse of the African homeland shore before they lay spoon-fashioned in the bowels of slaving ships, chained to tribal family, friends, and enemies who would soon become auction block companions. Stranger-to-stranger hospitality continued when many African American women raised the children of women sold to other plantations, the children of the masters who raped them, and the children of the mistresses who brutalized them. In short, we learned to be hospitable in hostile environments.

I am not presupposing that African American women's faith is the only faith and their response of hospitality is an exclusive response of an exclusive faith. I want to draw, however, connections between the middle passage experience, enslavement, and contemporary time. African people knew Christianity (a relatively young religion), but for the most part, they were polytheists; many came from matriarchal religions. For Africans becoming American Christian, loss as well as a finding of salvation were both present. The spiri-

tuality that I sense and am trying to convey is a spirituality that, while practiced in a new form, is ancient. Spirituality is older than conversion to Christianity (or Judaism or Hindu, etc.). While I am focusing on the form of spirituality I found among the women of the Literary Group, and many other African American women of today, I insist on holding them on a continuum, in harmony, with others as well as with older forms, so that the hospitality offered can be both true to one religion and its forms and yet also informed and open to others. The particularity of the hidden gatherings does not create boundaries of nor for exclusivity (though I understand that "religion" is too often about exclusivity). The hidden gatherings are oases "for a while," used for healing, rest, and release. The analogy of turning back to ancient traditions that were not Christian (some practices, but not all, were lost in conversion) is a pointing toward, not away from, our common humanness with "then" and "now" and "yet to be" humanity. The precious gift of concealed intimacy is not lost to the gift of openness, nor vice versa. Both must exist in contemporary time—I suspect—if for no other reason than our own frail humanness.

Stranger-to-stranger hospitality, then, grows out of the ancient and immediate need for faith and for church. The church, turning away from the needs of African American women, is creating a bound-up experience for them in both pulpit and pew. The African American church, refusing to give sanctuary, actively participates in keeping women as strangers, in keeping women constrained. This constraint, experienced as brutality, does not necessarily strip African American women of dignity:

DRESS UP OVER MY HEAD
(FOR FANNIE LOU HAMER)

if/when you find me
guttered
lips cracked & busted

hair matted
face swollenswollenswollen
eyes wet with tearlessness

if/when you find me
in a smokey back room
of hell
on floor between
knobbed legs
knees bleeding
pleading gone

if/when you find me
surrounded confounded
laid down flat on my back
haunted by hants
squirming under

lovelessness & hatred

if/when you find me

eating out
my own heart
sinking into
my own casketless grave

i simply ask
if/when you find me
that if my dress
is up over my head that
you
would
gently
smooth
it down.

In the midst of the hostile environment of church and the
oppressive society where the wounds of racism and sexism

are deep, African American women yearn for hospitality. It would be wrong to think that, as strangers, African American women are so calloused that they choose to remain strangers. Audre Lorde's poem "Harriet" paints a poignant description of the yearning for hospitality among Black women:

> Harriet there was always somebody calling us crazy
> or mean or stuck-up or evil or black
> or black
> and we were
> nappy girls quick as cuttlefish
> scurrying for cover
> trying to speak trying to speak
> trying to speak
> the pain in each others mouths
> until we learned
> on the edge of a lash
> or a tongue
> on the edge of the other's betrayal
> that respect
> meant keeping our distance
> in silence
> averting our eyes
> from each other's face in the street
> from the beautiful dark mouth
> and cautious familiar eyes
> passing alone.
>
> I remember you Harriet
> before we were broken apart
> we dreamed the crossed swords
> of warrior queens
> while we avoided each other's eyes
> and we learned to know lonely
> as the earth learns to know dead

Harriet Harriet
what name shall we call our selves now
our mother is gone?[15]

The poet's voice reminds Harriet that loneliness had to be learned just as the earth, not born to die, must learn to know the dead. Just as the earth was not intended to know dead, so Black women were not intended to be estranged one from another. Among other things Lorde teaches in this poem is that inhospitality, for African American women, is like the breaking apart and dismantling of belief in tribal beauty and ancient traditions that African American girls and women have sometimes tried to use as stories of affirming selves and lives that are otherwise hard to bear, hard to value. The ancient traditions can be essential as sources of positive roots (the stories all cultures choose to tell themselves) in this contemporary time if we are ever, as strangers, to become resilient:

SHE & ME

They told Me
 She is stranger
 Me believed
They told She
 Me is stranger
 & She believed

Unbeknownst to Me or She
Me stands in She's shadow
Nearly starve of loneliness
Were it not for
Familiar rhythm pulsing

From She to Me.

15. Audre Lorde, *The Black Unicorn* (New York: W. W. Norton, 1978), 21.

African American women, innovative and resilient, provide hospitality for each other in many, many ways. The hospitality of concealed gatherings is one such method.

Hospitality in Concealed Gatherings

Rising to the challenge of reinterpreting reality, speaking truth, making clear messages available, women will congregate in concealed gatherings.[16] As a strategy for resilience, African American women carve out a niche of intimacy through such gatherings where they have neither to defend nor to deny their place or their humanness. This special place is not at every event of gathered women. African American women gather in work places, in churches, at sorority meetings, in the marketplace, at the hairdressers, and in laundromats, yet these particular gatherings are not necessarily gatherings of intimacy. Every group of congregating Black women is not intended for intimacy and does not feed resilience. In the concealed gatherings that foster resilience, genuine hospitality is shared for African American women by African American women; a stranger-to-stranger hospitality. Concealed gatherings, when done with intent, have everything to do with "an education in life, in being black women, in dealing with the world, in deflecting the threatening blows, in relating to men, and loving (or at least not hating) themselves as blackbrownbeigecreamdamnnearwhitewomen with straightcurlybushykinkylongdamnneardowntothewaistmediumshorthair and breasts and hips of varied and sundry descriptions."[17] The character portrayed by Spike Lee in the film *Jungle Fever* called such gatherings of women "war councils." These kinds of concealed gatherings have also been called "hen parties."

16. See Daryl Cumber Dance, *Honey, Hush!* (New York: W. W. Norton, 1998), concerning the notion of "concealed gatherings" as well as descriptions of gatherings of African American women.

17. Ibid., xxvii.

Be they war councils or hen parties, reminders of real or mythical village experiences or claimed as new inventions, these gatherings are distinguished by raucous bantering, comic tales of then and now, outrageous anecdotes, new/old jokes, playing of the dozens, snappy comebacks, dissing, sarcasm, absurd and sick humor, lies, philosophizing, theologizing, recited poetry, new poetry, tired clichés, sage wisdom, tales of how we got over, stories of back when and back then, dreams of right living, right loving, and new ways of being. The gatherings are high energy and fast-paced events. The conversation is loud, verbose, and magically rhythmic. The gatherings are loud, boisterous, and rowdy. The rhythm of the conversation is often syncopated and double syncopated with several women talking at one time—a varietal symphony of verbal and bodily expression. The gatherings are verbally and linguistically treacherous—not for the dull, slow, or faint of heart.

Laughing for Healing and Mending

The Dear Sisters' gatherings demonstrated a primary characteristic of concealed gatherings, i.e., the gatherings are laugh-fests. The gatherings are women laughing with each other rather than at each other. Women laugh about men, jobs, White people, neighbors, preachers, race, gender, pets, hairdressers, and wardrobes then and now. At these gatherings, dignified, socially adept "ladies" ungirdle and transform themselves, even for a little while, into Black women—loud, free, and wondrous. Delores Marshall (1996) described the gatherings:

It's just a sisterhood there and it's a warm feeling. We know that we can talk about anything. We can say anything. We can talk about our husbands. We're joking about them. But it's a love there that we are talking about. But it's an understanding that we have our own kind of vocabulary. And we have our own kind of understanding. Whereas if

there were someone else in there (White or male), it would be cold. We wouldn't [talk openly or freely]. We have a good time at our meetings.

Women gather around, usually at a table in a comfortable kitchen, to talk, giggle, bless, curse, exorcize, banter, cackle, debate, blow off steam, vent, laugh, and talk some more, for hours and hours and hours. These concealed gatherings are occasions when time is suspended.

The laughter shared at concealed gatherings is not a note of whimsy or a tickle or a display of delight during a social occasion. African American women laugh to keep from going off, to keep from disappearing, to keep from speaking out of turn, to keep from imploding, to keep from lashing out, and to keep the craziness from overtaking the sanity. African American women laugh, not for social etiquette, but to heal and to mend ourselves and each other. Sherry Jones (1996) describes it this way:

Now this may sound strange, it may sound prejudiced but I don't think anyone laughs as deep in the belly as Black women. Laughing about our mothers, relationships with our mothers, relationships with our lovers, relationships with our God [to] the point where the laughter is healing. The enjoyment of each other's struggles. I don't know how to explain that. It's almost spiritual. . . . It's just that the laughter is healing.

And Connye Brown (1996) said:

[When I am with my gathered sisters] I can say what I want to say. I can laugh, which is cathartic. I can really laugh and I think the people really see you for yourself and since as far as I know they are Christian women, they really care for you, not you as a person or what you are wearing or anything. That's just really important in my life—having people caring for each other, laughing with each other.

Daryl Cumber Dance, editor of *Honey, Hush!*, poignantly writes about the use of humor by African American women:

Humor hasn't been for us so much the cute, the whimsical, and the delightfully funny. Humor for us has rather been a means of survival as we struggled. We haven't been laughing so much because things tickle us. We laugh, as the old blues lines declares, to keep from crying. We laugh to keep from dying. We laugh to keep from killing. We laugh to hide our pain, to walk gently around the wound too painful to actually touch. We laugh to shield our shame. We use our humor to speak the unspeakable, to mask the attack, to get a tricky subject on the table, to warn the lines not to be crossed, to strike out at enemies and the hateful acts of friends and family, to camouflage sensitivity, to tease, to compliment, to berate, to brag, to flirt, to speculate, to gossip, to educate, to correct the lies people tell on us, to being about change. Ultimately we recognize, as Toni Morrison has written in *Jazz,* "that laughter is serious." More complicated, more serious than tears.[18]

Laughter expresses the pent-up power, the anxiety, and the joy of many African American women. The effervescent laughter at hen parties is power expressed behind closed doors based upon a shared experience. It is the expression of that power which harnesses the essence of an African American woman's spirit. Patrice Gaine's novel, *Laughing in the Dark,* paints this portrait of the profound use of the power of laughter by African American women while gathered in a jail cell:

We went on like that for twenty minutes or so, talking shit, embellishing tales, joining, until we couldn't stand it anymore. Then we fell asleep, exhausted from our lies and our longings. We fell asleep content too, in a way in which many of us had never been with our men. We gave each other laughter to help us through the night.[19]

18. Daryl Cumber Dance, *Honey, Hush!* (New York: W. W. Norton, 1998), xxii.
19. Patricia Gaines, *Laughing in the Dark* (New York: Crown Publishers, 1994), 117.

Body and soul are reconnected through laughter. "Laughter is not simply funny; it's serious medicine; it's righteous therapy."[20] To laugh deeply is to reconnect, reembody body, emotion, intellect, and will:

<div align="center">

LAUGH

(FOR CONNYE BROWN)

</div>

(UMM, I don't
 find it easy
 to cry
 but, laughter,
 that's different ...)

laugh often
deep down belly deep
like God laughs

laugh outloud when you are nervous
don't know what to do or
where to put your hands
laugh just for the fun of it—
to make someone else giggle

laugh when you should be crying
don't forget
return to the cry
later on

laugh when you must decide between unwanted choices

laugh when there's trouble
need to hush up fault/blame
when you don't have
answers to questions
just to buy time to think

laugh when you are being polite
(cause it was not funny)

20. Daryl Cumber Dance, *Honey, Hush!* (New York: W. W. Norton, 1998), xxvii.

when they annoy you
when they get on your nerves
especially
when they get on your last nerve

laugh to mark time
enduring all those meetings
waiting in all those lines
sitting in all those traffic jams
swallowing all that pride

laugh instead of committing mayhem [harry carry]

learn to laugh at yourself
family can help with this
just when you think you be "Miss It/Miss Thang"
family reminds you they knew you long before your
"it-ness"
came along & you got too big fo' yo' britches

rather than kick yourself
laugh
rather than let someone else
kick you
laugh then jump out the way

rather than stay stuck
muster up courage
get unstuck
then laugh as you tell
your story of triumph
laugh because it makes you look like you know

laugh with your sistahs
they understand
difference be-
tween
at you & with you

laugh it lubricates prayer
makes place for peace
causes you to breathe deeply
utter loudly
gasp wildly
 laugh because too many would prefer you not[21]

The response of stranger-to-stranger hospitality for African
American women by African American women is rooted in an
understanding that the body and the soul are intertwined, in-
terconnected, interwoven. Stranger-to-stranger hospitality is
soul work for broken bodies. This kind of hospitality is body
work for bruised and battered souls. Laughter reminds us of
who we are and whose we are—made in the image of a God
who enjoys a deep giggle and a well-delivered punch line.
Laughter engages the whole body—physical, emotional, in-
tellectual, and willful. Laughter places and replaces us within
our whole bodies.

Language and Rhythm

The language of the conversation is sparkled with split verbs,
double negatives, dangling participles, double comparisons,
verbal nouns, and rhythmic repetitions. Intertwined in the
name calling, tales, and hyperbole are references to popular
song lyrics, biblical verses, old and new song lyrics, adages,
and slang. Often times only pure rhythmical sounds are
woven into the conversation with the sucking of teeth, blow-
ing and gasping of air, moaning, and cacophonous laughter,
screams, screeches, shrieks, and shouts. The collective rhythm
of the gatherings is like that of "down home" prayer meetings
or old Southern church revivals or present-day pentecostal
worship services. There is an ebb and flow—a soothing,
sinuous, energetic tide to the conversations and the entire ex-

21. The first stanza of this poem is a direct quote from Connye Brown during our
interview.

perience. The vaporous feeling of being "at home," like a fine mist on a green meadow, intoxicates the women.

At times, the room stills, even if the noise level does not drop. The laughter halts. These are usually deadly serious conversations and situations that need special attention and particular concentration. The stilling conversations usually signal dire situations like a sick child, a delinquent mortgage, a philandering husband, or the death of a loved one. In these stilling situations, the rhythm might slow but it does not cease. The banter might modulate but it does not stop. Once the situation is "dealt with"—putting a strategy in place, invoking a blessing or curse, simply venting or exorcising—the laughter returns—full, voluptuous laughter.

Sensuous Experiences

The gatherings are sensuous events. A woman's body is a full participant in the gatherings. Each women uses her own body parts to reenact the story, usually without ever leaving her chair. The drama comes from head bobbing, neck swiveling, hip swaying, finger pointing, teeth sucking, eye rolling, and other gyrations. Several of the women possess and are known for their own style, comic timing, and unique use of language. The women know when to drop in the playful insult, when to let the silence linger, when to say the new punch line just in time. "It's just plain fun," describes Donna Jones (1996), "and there are times that we can sit and say things that you don't have to have an explanation, because you've been there. It's that thing that we know we deal with, sexism and racism in our lives."

The sensuousness of the occasions also comes forth, as always, in the sharing of food. The "Dear Sisters' Literary Group" is an excellent example. Food, as a sensual agent and important component of concealed gatherings, eventually emerged for the sisters, though it took some coaxing and a little time:

Power from Deep Within

Gather Women
draw up power from deep within
dare to conceal thresholds
into bosoms of secret
kitchen nurture & back room care
venturing where
time finally
still-less & pleasant
smiles a weather-worn grin

with anticipation exhaustion conviction
in seamed garments
beautiful wounded able Gather—
Women with laughter/strength
that shouts down hatred
with sorrow
that breaks Jesus' own heart
with warrior's courage
that keeps satan at bay

Gather Women
re-mind re-member re-embody
ancient-eternal-yet-to-be-born truth Truth
Truth tellin'
 listenin' shoutin' screamin'
 of love & loss
 death & resurrection
 trouble that don't last always

Tellin' of
 he who
 with disgrace/dishonor/beguilement
 dare to lay & lie & betray

Speakin' on
 previously squandered self
 on ironed sheets of lovelessness

Confusin' to
fights won/lost
against rapist/murderers
self given-freely
having been rudely returned
bankrupt & stale

Shriekin' 'bout
triumphs in battle
having beaten rats
from our own nipples
lest our babies go without milk

While telling brews
We eat
dine feast
sup food cooked with love
by eldest love

We drink
gulp swig
sip

We suck
sample nibble
devour

nectar blood essence

Never quite disclosin'
roux of healing lovin' livin'

All while gumbo-ed salve conjurin'

swirlin' twirlin'
Gather-Women grow

loud LOUDER correct
opinionated
laugh & LAUGH

heads bobbin' gyratin'

hips shakin' swayin'
teeth suckin' dancin'
necks swivelin'
necks archin' fingers poppin'
teeth suckin' eyes rollin'
laughin'
laughin'
LAUGHIN'

again & again raucous
explodin' EXXPLODIN'
yes YES

with PLEASURE again yes YESYESYES
same as no, better than
orgasm

Oh thank you sweet Jesus! yes![22]

Why Conceal?

Daryl Cumber Dance suggests that these gatherings of hos-
pitality are concealed for three reasons. First, in an age
when social grace or etiquette is not often an issue, it is still
considered "improper" or "niggerish" behavior by African
American women to show great emotion, laughter, or ro-
bust body language that might offend or be misconstrued
by White people. Raucous behavior, says Dance, is partic-
ularly offensive in public and especially when witnessed by
White "ladies" who are easily taken aback. Second, even in
this day and time, telling jokes is considered "unladylike."
Joke telling, with its bawdiness, is still for men. Dance re-
minds us that African American women struggle against the

22. The phrase "power from deep within" comes from bell hooks's book *Sister of
the Yam*. I read the phrase and heard this poem.

personal stereotypes of "grinning imbeciles" and "laughing clowns." And finally, Dance reports that African American women do not want to lend credence to stereotypes of Black humor. Black women, then, may not laugh in public because we do not want to be willing participants in our own oppression—personal or corporate.

Additionally, I would suggest that African American women conceal their gatherings for the same reason that a good cook never tells the secret of her roux. A roux is a paste of butter and flour used to thicken and color gumbos, stews, gravies, and soups. The best cook never tells the secret ingredient that makes her particular stews and gravies so tasty. Keeping the gatherings concealed is like keeping the secret of the roux. Like the roux, the gatherings bring color and thickness to the lived experience of African American women. The secret is passed from generation to generation as a blessing to the family for the blessing of the village.

BOSOM OF GRANDMA

My Grandma's
soft strong calloused hands
reached in & down down down
 in & down down
 down
 down
 down

Her soft strong calloused hands
reached in
past the handkerchief
her grandmother embroidered
for her own wedding

past wadded money
kept only for
dire emergencies

past peppermint
 candies & butterscotch
 lifesavers
past scar tissue from
brokenheartedness
of her first
& only
love

Grandma's hand reached
 down
 down
 down

into her bosom
into her self
She reached down
past her own armpit
past her own breast
past her own elbow

Grandma reached
into her most ancient
most needed self
she reached down & pinched off
just a tad
just a bit
just enough

She pinched off
pinched off a piece
like a baker
pinches from fresh yeast dough
she pinched off
a piece
like a sculptor
entranced in her clay

she reached down
pinched off
a piece
of the ancestor's marrow

Just a pinch
of marrow
did she add to the boiling cauldron
marrow thought lost
in the Middle Passage
 to rot at sea's dank bottom
 but no
marrow thought lost
in the master's hatred
 savage torment of soulless rage
 but No
marrow thought lost
 in the sweat shops
 in the dung heaped ghettos
 in the welfare lines
 in the shattered minds
 OH, BUT NO

My Grandma reached down/in
& with a pinch
added to the conjure pot
stirred with wooden spoon
& hummed
She hummed & a smile
graced her lips
she stirred hummed smiled
for she knew
that she knew
that she knew.

ꙮ 4 ꙮ

Doing
Womanist Theology
with Dear Sisters

Womanist theologian Jacquelyn Grant writes, "To do Woman-
ist theology...we must read and hear the Bible and engage
it within the context of our own experience. This is the only
way that it can make sense to people who are oppressed."[1] For
Womanists, says Grant, the Jesus of the Bible is in dynamic con-
versation and connectedness with the everyday experience of
the Jesus who walks and talks with African American women.
The experience of Jesus is the central frame of reference be-
cause Jesus identifies with us and we in turn identify with him.[2]
The suffering, death, and resurrection of Jesus is understood
to be the suffering, death, and resurrection of one who was
fully human while at the same time being fully divine. Jesus is
God incarnate—able and willing to identify with and be iden-
tified by the suffering of African American women of history
and of contemporary time.

Grant reminds us that the agility of African American

1. Nantawan Boonprasat Lewis, Lydia Hernandez, Helen Locklear, Robina
Marie Winbush, *Sisters Struggling in the Spirit: A Women of Color Theological
Anthology* (Louisville, Ky.: Presbyterian Church (U.S.A.), 1994), 186.

2. For further conversation concerning Jesus as the central frame of reference for
Black women, see especially Kelly Brown Douglas, *The Black Christ* (Maryknoll,
N.Y.: Orbis Books, 1994).

women to do theology where we are, how we are, and because we are is poignantly displayed in the life and teaching of Sojourner Truth. Sojourner Truth, preacher and activist, was asked by a fellow preacher if the source and power of her preaching was from the Bible. Sojourner Truth replied, "No honey, can't preach from the Bible—can't read a letter."[3] Then Sojourner explained, "When I preaches, I has jest one text to preach from, an' I always preaches from this one. My text is, 'When I found Jesus!' "[4] Sojourner's inability to cipher the biblical text did not hamper her ability to do theology. African American women during slavery and since have understood that Jesus identified with the plight of the weak, the poor, the downtrodden, the marginalized, the outcast, the misunderstood, the abused, and the scorned. Jesus identifies with, understands, and embraces the struggle of African American women. In doing Womanist theology in the everydayness of their lives, African American women understand the profound notion that the empathy and compassion of Jesus exists for them, then and now.

Moving into Communion and Sacramentality

Jacquelyn Grant employs Harold Carter's account of a prayer by a slave woman to describe the theological facility of African American women of long ago:

> Come to we, dear Massa Jesus. We all uns ain't got no good cool water for give you when you thirsty. You know, Massa, de drought so long, and the well so low, ain't nutting but mud to drink. But we gwine to take de 'munion cup and

3. *The Narrative of Sojourner Truth* (1850 edition as dictated to Olive Gilbert), ed. with an introduction Margaret Washington (New York: Vintage Books, 1993), 11.
4. Ibid., 119.

fill it wid de tear of repentance, and love clean out of we
heart. Dat all we had to gib you, good Massa.[5]

This prayer depicts the intimacy felt between this woman and
Jesus and the power of the hospitality embodied in the com-
munion cup. This woman had nothing, yet she yearned to
give to Jesus. She had faith that it was in the communion cup
that her nothingness would be transformed into love.

Christian, African American women today, like the women
of old, commune with Jesus. We depend upon the incarna-
tional Jesus to transform our nothingness into love. We use
the experience of "de 'munion cup" to invoke the power of
Jesus to transform our lives. God is present in all of life.
This sacramental view of life knows that humans have the
power to create thresholds through rituals that illuminate the
sacredness of every aspect of life. A sacramental worldview
espouses that " . . . the sacraments (are) religious rites through
which God breaks into our otherwise secular and nonreligious
everyday lives."[6] All of life is sacred, thus all experiences are
sacred—there is no such thing as secular. So, even though the
language of the women interviewed is not filled with religios-
ity (though there are many references to blatantly Christian
notions), the spiritual dimension of the concealed gatherings
is apparent for people who can discern. The doing of theol-
ogy is an everyday occurrence of dynamic conversation and
connectedness with the sacred. Concealed gatherings are one
way that the presence of God is illuminated in the everyday
occurrences of life.

Sacramentality

The narrow view of the term *sacrament* limits it to the two
ritual essentials in most Protestant churches and the seven

5. Harold Carter, *The Prayer Tradition of Black People* (Valley Forge, Pa.:
Judson Press, 1976), 49.

6. Robert L. Browning and Roy A. Reed, *The Sacraments in Religious Education
and Liturgy* (Birmingham, Ala.: Religious Education Press, 1985), 4.

essentials of the Catholic Church. A narrow view of communion limits it to "a rite in which God pours out grace in a special way by actually changing, through the priest's words and actions, the bread and wine into a new substance, the body and blood of Christ (or the understanding of) communion as a memorial for Jesus Christ."[7] There can be broader, more imaginative ways of viewing sacramentality.

Sacrament, in its broadest definition, is any profound experience that puts us in touch with the very mystery of life, thus putting us in touch with God. "(A) sacramental experience is anything that puts us in contact with deeper realities and ultimately with God."[8] Through Jesus, we can encounter God. Jesus is, for Christians, the ultimate sacrament of God. The Hebrew Bible is a record of the sacramental events and prophetic persons of the ancient Hebrew people.[9] The creation story; the story of Abraham, Sarah, and Hagar; the conquest of the promised land; the story of David the boy and the King; the Exodus by the Hebrew people from bondage in Egypt—all can be perceived as sacramental events where lives were changed as a result of having touched, experienced, and encountered God. There is a sacramentality inherent in living life.

Christian belief and theology has stressed the importance of the natural world, the physical world, and the material world as a way for human beings to converse with God. Grace is embodied not in abstraction like virtual reality, but in tangible things—in real bodies and real gatherings. Sacramental experiences are experiences of persons' bodies, emotions, intellect, and will coming to deeper knowledge and love of God. Jesus is fully divine, but more to the point, he is fully embodied in a human body: a compassionate and empathic God who does

7. Ibid., 5.
8. Richard Reichart, *Teaching Sacraments to Youth* (New York: Random House, 1987), 5.
9. Ibid., 7.

not need an explanation about pain or pleasure, suffering or
joy, despair or ecstasy.

The sacramentality of life is ritualized in many ways. Some
of the rituals are "official," having been sanctioned by the
church. The rituals of baptism and Eucharist are considered
to be the sacraments of most Protestant churches. I would
suggest that among Christian people rituals and ritualized
behaviors exist that have sprung from early church prac-
tices, just as did baptism and Eucharist, but which are not
recognized as sacraments by the official church, and which
are powerful encounters with God. One example of such a
ritual is the love feast taught to lay preachers by John Wes-
ley, father of the Methodist denominations. Wesley preached
"the priesthood of all believers" and ritualized this belief by
empowering laypersons. I would suggest that concealed gath-
erings for African American women are also sacramental in
nature and are rooted in the long history of laypersons, in this
case women, immersing themselves in the sacramental phe-
nomenon of Holy Communion through the sharing of food
in and for intimacy, trust, and reciprocity.

What "hallows a space is what happens there."[10] In shar-
ing hospitality with one another, Christian, African American
women create space where wonder can be revealed from
within each other, for each other, by Jesus the Christ. In Alice
Walker's novel *The Color Purple,* a female character named
Shug Avery reminds another character, Celie, that God is
present inside her. Shug simply says, "Here's the thing.... The
thing I believe. God is inside you and inside everybody else."[11]
Concealed gatherings create thresholds for the God within
African American women to be revealed. The revealing of
God in concealed gatherings is a hallowing of kitchens, an
immersion in Holy Communion.

10. Elizabeth Dodson Gray, ed., *Sacred Dimensions of Women's Experience*
(Wellesley, Mass.: Roundtable Press, 1988), 7.

11. Alice Walker, *The Color Purple* (New York: Harcourt Brace Jovanovich,
1982), 177.

The breaking of bread, the sharing of a common meal is central to the Christian experience of grace. Our contemporary ritual of Holy Communion is grounded in the experiences of the last Passover Jesus shared with the disciples and the meal Jesus shared with Cleopas and the unnamed stranger in Emmaus after the resurrection. On the night of the Passover feast, Jesus gives to his disciples a cup of wine, which he calls "the fruit of the vine" (Luke 22:17–18; Mark 14:25). Jesus takes bread; blesses, breaks, and gives it to his disciples; and says: "This is my body. Do this in remembrance of me" (Mark 14:22; 1 Cor. 11:24). Luke 24:30–31 (NRSV) says:

> When [Jesus] was at the table with them, he took bread, blessed and broke it, and gave it to them. Then their eyes were opened, and they recognized him; and he vanished from their sight.

At Jesus' table, when bread is shared, strangers are recognized as beloved. After Pentecost, believers "devoted themselves... to the breaking of bread" (Acts 2:42) and "breaking bread in their homes, they partook of food with glad and generous hearts, praising God" (Acts 2:46–47). Not surprisingly, Paul is found with believers "gathered together to break bread" (Acts 20:7) on the first day of the week. "The line runs straight and true from the last supper through the post-resurrection meals in the upper room to the 'breaking of bread' in the early Church and in the Lukan tradition these meals, like the last supper, are evening meals."[12] The people of God have historically gathered for a meal characterized by overwhelming joy (Acts 2:46). Contemporary Christian, African American women gather, like the Literary Group in my home, for meals characterized by overwhelming joy. There is a sacramentality about these gatherings.

12. Neville Clark, *An Approach to the Theology of the Sacraments* (London: SCM Press, 1956), 49–50.

A Story about Sacramentality

It had been a long day. By 5:30 P.M. I was tired and not really interested in preparing for the Dear Sisters' meeting that would gather at my home at 7:00 P.M. Out of a sense of loyalty and obligation to the group, I prepared for their arrival. I brought chairs to the living room to accommodate twenty women. I set the dining room table for the potluck dishes. I placed candles around the room and on the table. I cut flowers from my garden and placed fresh arrangements in the living room, dining room, kitchen, and bathrooms. All was ready. The first sister arrived at 7:00 P.M. We greeted each other with a hug and she handed me a plate of freshly baked bread. By 7:30 P.M. I had received fifteen hugs and fifteen bags of food, and fifteen women sat talking and laughing in my living room. The next arrival was a sister who had missed the last month's meeting. The energy in the already lively room escalated as the women warmly greeted the previously absent sister and requested an accounting of her whereabouts.

The group settled in, had a brief business meeting, made plans for the future, then conversed about the book of the month. The book was *Blanche Cleans Up* by Barbara Neely. The book's central character is a maid in White folks' homes. We had read the previous book by Neely entitled *Blanche on the Lam* a year earlier. Most of the women liked Blanche and liked Neely's style of writing. The conversation turned easily to personal experiences and memories of mothers and grandmothers who had been domestic workers, day workers, maids in White homes. Women recalled helping their own grandmothers serve meals, clean, and chauffeur for White folks. The parallels between their recounts and the Blanche story were remarkable. Two women recounted feelings of resentment and disgust when the White children would call upon their grandmothers with family problems or during personal crises. One woman said, "She's our grandmother, not yours." She then recalled how her grandmother never turned away a

call or a visit from the emotionally needy White family—how she was always gracious and giving.

The stories of African American women doing their day's work lasted for some time and had great resonance in the group. Near the end of the discussion I prepared the meal. Another woman joined me in the kitchen. We took food from the ovens, refrigerator, and freezer. I lit the candles on the table, then called my sisters to the table. We gathered in a circle around the table and a prayer of thanksgiving was offered. We served our plates, complimented the cooks on recipes, and talked about national and international events until 11:00 P.M. About 11:00 P.M. we said our good-byes. As I was cleaning up, I realized I was no longer tired.

Sacramentality of Concealed Gatherings

The sacramental nature of the hospitality I am discussing is born out of the love of Jesus for strangers, born out of the compassion of Jesus for humanity, born out of the grace of God who loves the entire world. These concealed gatherings bring into focus the profound truth that "In the beginning was the Word... and the Word became flesh and dwelt among us, full of grace and truth" (John 1:1, 14, RSV). The sacramentality of concealed gatherings is an encounter with the incarnate Christ, thus an encounter with grace. A Catholic adage says, "The sacraments conceal what they reveal."

Like any ritual sacrament, these concealed gatherings have an intrinsically powerful sacramental character. Through certain meaningful signs, we cooperate in a shared process. We look backward to past events, we celebrate the present moment of life, we look forward to the future. This process is enabled by commonly accepted language, bodily gestures, and behaviors.[13] Women bring their bodies to the sacramental ex-

13. Ibid.

perience. The incarnation of Jesus is proof of the importance of the body as a means of grace. The storytelling and banter, the laughter, the prayer before the meal, and the shared meal are commonly accepted in the concealed gatherings for recalling and representing the original event of the Last Supper. At these gatherings, the original event of the Last Supper is reexperienced and the current event is hallowed. The sacramental experience recalls the past, while at the same time blessing the present and beckoning that the people move into the future with steadfast hope.[14]

The women in the group report leaving the gatherings exhausted while at the same time refreshed and renewed. The paradoxical coupling of exhaustion and refreshment are marks of sacramentality because African American women, attending the gatherings as "home" events, are open and expectant. "What makes human experiences sacramental encounters is our openness to and discovery of the person of God in the experience."[15] Women reported that nowhere else other than in the concealed company of their sisters did they feel as open, as relaxed, and as able to speak and hear the truth. Being so open to themselves and one another assuredly opens one to God. The sacramentality makes available the enfleshment of Jesus. The dominion of Jesus becomes a "now" experience with their bodies for healing, strength, nourishment, self-affirmation, and power.

Fulfilling the Priestly Function

The profound, I am repeatedly suggesting, can be invoked from within the ordinary. The Eucharist celebration is the extraordinary revealed in the ordinary; the essence of Goodness found within grain and fruit, bread and wine. The partaking of common elements for the holy edification of

14. Ibid.
15. Ibid., 13.

the human body and soul is a great mystery. Mystery is not that about which you can know anything; mystery is that about which you cannot know everything.[16] Mystery is "the infinity of questions with which every answer confronts the human mind," body and soul.[17] There is in the gathering of women the great mystery enfolding, unfolding, never to be fully known, but beckoning still. The profound is invoked and evoked by African American women from the ordinary experiences of our lives while we gather around kitchen tables, just as the ordinary was evoked by the strangers at the Emmaus table.

Women are, in this sense, priests preparing communion when we breast-feed our newly born babies, prepare peanut butter and jelly sandwiches for school lunches, cook for days preparing festival feasts for our families, or prepare a fire and make tea for friends who stop by to visit.[18] Like the church priests who are caretakers of the chalices and plates, women are priestly when we scour our pots and pans, set tables, light candles, and say grace over the meal. Connye Brown (1996) described her priestly mother in this way:

> I just remember my mother always trying to feed us well. She wanted you to eat and be healthy. My mother was a very religious woman, a Christian woman. Uneducated, and she just filled her life with just being a loving mother—sending you to school—regular school and Sunday school—and you were to take care of your school work and to learn to love the Lord and to serve him. Those were the two basics that she gave us.

Connye's mother is a typical expression of African American women being ordinary mamas doing sacramental things in the everydayness of life. The story of the Emmaus road

16. I originally heard this notion from Dr. Maria Harris in a workshop on Religious Imagination at Auburn Seminary, New York, 1989.

17. Paul Tillich, *Systemic Theology*, vol. 3 (Chicago: University of Chicago, 1963), 8.

18. Gray, *Sacred Dimensions of Women's Experience*, 170.

powerfully teaches us that "whoever does the work of prepa-
ration becomes the priest, weaving the fabric of life as the
sacred ordinary work of the everyday."[19] Jesus, in pouring
out his compassion and hospitality at the table, brought a
new covenant to the world and opened the eyes of strangers
to recognize faith kin. Christian, African American women,
as priests doing the work of preparation by weaving the fab-
ric of life, invoke the compassion and hospitality of Jesus for
ourselves when we gather, transforming us from strangers to
kinfolks.

At concealed gatherings, African American women while
eating, drinking, talking, teasing, and laughing are our most
uninhibited selves and are seated at the table of Jesus in the
Holy Dominion. Sharon Taylor (1996) said:

> I think it's like a oneness occurs. It's like a sense of harmony.
> Because at that point there's no other men there and we all
> are sisters. And we can share some private areas. And we
> know that it's OK. Because it's a sister thing going on there
> now. And I just think that's fantastic. And now harmony is
> there. That's the only way I can say, it's a sense of harmony
> and freedom.

The Literary Group broke out in communion even when
there was a concerted and misguided attempt to hold it back.
Or perhaps, communion broke out in us, realizing what our
grandmothers knew—that women gathered together are com-
pelled to commune together on the deepest level; we need to
ingest one another and devour our very own selves as an ex-
pression of mutual support, a witness of connectedness as an
affirmation that God is in our midst and within us. Brenda
Hutter-Simms (1996) said:

> Somebody is going to break bread. . . . I know that one per-
> son is going to come in because she bakes bread all the
> time so you know those sensuous, mouth-watering urges

19. Ibid., 187.

are going to get filled. You are going to wonder, well what
are people going to bring and what are you going to bring?
You are going to see people that you haven't seen for two
months, maybe. We may play a game. Maybe whoever's
house it is may say or read a poem. No matter what hap-
pens, there is a feeling that is so so so deep that it's like
magic. It's like smooth and warm and satisfying.

In receiving our guests, coming together as strangers in the
world that does not rightly know them, African American
women, as strangers, invoke the power of the Holy Spirit.
The gatherings are a return to wisdom without romanticism;
a tribal reconfiguration without nationalism; an invitation to
return to the center and to commune with the divine. The
gatherings rest in the assurance of Jesus' promise, "where any
two or three are gathered in my name there I will be also"
(Matt. 18:20).

Sacramental events are not, then, limited to the Eucharist
at church altars, nor are sacramental encounters reserved for
a sanctuary with full public worship. The mystery of God
dares to break forth in church and out of church, with church
officials and in their absence, but always for the blessing of
the people of God.

Truth, Double Consciousness, and Unmasking

Concealed gatherings are also sacred space because truth can
be spoken there. This disclosed truth is a truth that is prohib-
ited in the presence of White people and in the presence of
Black men. Psychologists and most healthcare practitioners
emphasize the necessity for and the link between the dedica-
tion to truth and the capacity to be healthy, the capacity to
be well, and the capacity to be resilient. M. Scott Peck, au-
thor of *The Road Less Traveled,* says that one of the roots
of mental illness is invariably an interlocking system of lies

we have been told and lies we have told ourselves.[20] Concealed gatherings make space for the voicing of opinions that have been shouted down, for the voicing of facts that have been twisted, for the voicing of woundedness that has been denied, denounced, and disavowed. Howard Thurman said, "There must always be the confidence that the effect of truthfulness can be realized in the mind of the oppressor as well as the oppressed. There is no substitute for such a faith."[21]

The concealment has turned W. E. B. DuBois's (1903) notion of double consciousness from a negative to a positive. DuBois wrote that one of the consequences of racism was that of "double consciousness." Double consciousness, as DuBois described it, is the necessity of oppressed persons to maintain two realities in order to survive. The two realities, one acceptable in the presence of White folks and the other acceptable in the presence of Black folks, required Black folk to negotiate two sets of truths, two sets of values, two understandings of self. Dr. DuBois believed that this double consciousness adversely affected African Americans, bringing to bear a strenuous crisis in identity. Dr. DuBois suggested that the struggles of doubleness lead only to further marginalization and despair. He explained it as follows:

> The Negro is a sort of seventh son, born with a veil, and gifted with second sight in this American world—a world which yields him no true self-consciousness, but only lets him see himself through the revelation of the other world. It is a peculiar sensation, this double consciousness, this sense of always looking at one's self through the eyes of others, of measuring one's soul by the tape of a world that looks on in amused contempt and pity. One ever feels this twoness—an American, a Negro; two souls, two thoughts, two unreconciled strivings; two warring ideals in one dark

20. Scott M. Peck, *The Road Less Traveled* (New York: Simon & Schuster, 1978), 67.

21. Howard Thurman, *Jesus and the Disinherited* (Nashville: Abingdon, 1949), 70.

body, whose dogged strength alone keeps it from being torn asunder.[22]

African American women, when gathering in concealment, are exemplifying DuBois's notion of double consciousness, but we have turned it from a negative experience to a positive experience. I would suggest that rather than being a detriment to Black folks, double consciousness has aided our people by equipping us with a worldview able to respond to a multi-cultural, postmodern reality. Double consciousness has given a "kind of creative edge over (our) adversaries, which is often ignored."[23] I would suggest that African American women demonstrate double consciousness, not for dominance and hierarchy, but for relating intimately with each other and with God. Carlyle Stewart also argues that double consciousness is an asset to our people:

> Double consciousness provides a way of responding to the world and enhances the self's creative capacities. The result is alternative and oppositional modes of being, the formation of critical consciousness, and the cultivation of a creative culture of spirituality that creates its own reality, and embraces, modifies, and transcends Anglo culture and society. To achieve this facility in a world which limited cognitive and behavioral possibilities is a remarkable feat. It is my contention that African American spirituality has had a vital role in transforming the devastations and inherent self-devaluations of double consciousness into positive and creative soul force.[24]

This positive interpretation of double consciousness is alluded to by the songwriter of this Negro spiritual, who no doubt wrote and sang in concealed gatherings:

22. W. E. B. DuBois, *The Souls of Black Folks* (New York: Bantam, 1903), 16–17.
23. Carlyle Fielding Stewart III, *Soul Survivors* (Louisville, Ky.: Westminster John Knox Press, 1997), 14.
24. Ibid., 15.

> Nobody knows de trouble I sees,
> Nobody knows but Jesus,
> Nobody knows the trouble I sees,
> Glory hallelu!

To be able to say "Hallelujah!" in the midst of sorrow and suffering is to embody the gift of double consciousness as a self-affirming, life-nurturing activity. Hallelujah! is in the concealed gatherings in the laughter, the banter, the food, and the sharing of heartfelt conversation.

The Hallelujah! that is possible in contemporary concealed gatherings is quite vividly displayed by well-educated, soft-spoken women, who, while in public, rarely laugh above a whisper, move very slowly and deliberately, and rarely speak out of turn. These same women, when in the safety of the concealed gathering, laugh uproariously, sway and move their bodies, and speak before, during, and after everyone else speaks. Double consciousness has assisted African American women in developing the dexterity—that is to say, the facility necessary—to make sense out of the contradictions of living in a White-supremacist, capitalist, patriarchal context.

Such dexterity is a source of joy because it can be openly claimed and is confirmed by others who really know what it takes and what it makes possible—one's sisters. For African American women, the necessity of balancing the two extreme poles of oppression vs. freedom, lowliness vs. dignity, object vs. human, insanity vs. sanity is an everyday, every moment struggle. It is a struggle that, in addition to requiring double consciousness, requires the wearing of a mask.

In writing the poem "We Wear the Mask," Paul Lawrence Dunbar captured the cloaked and contorted experience of African American women:

> We wear the mask that grins and
> lies,
> It hides our cheeks and shades our
> eyes,—

This debt we pay to human guile;
With torn and bleeding hearts we
 smile,
And mouth with myriad subtle-
 ties.
Why should the world be over-
 wise,
In counting all our tears and
 sighs?
Nay, let them only see us, while
 We wear the mask.

We smile, but O great Christ,
 our cries
To thee from tortured souls arise.
We sing, but oh the clay is vile
Beneath our feet, and long the
 mile;
But let the world dream other-
 wise,
 We wear the mask![25]

The concealed gatherings are times when African American women can take off their masks and be themselves, if only for a little while. Once the masks are removed, the lives and experiences of women, intricately woven with expressions of laughter and humor, bring healing and hope. "Hospitality creates a safe place for the speaking out loud of forbidden tales, forbidden truths."[26] It is a time of unguardedness: "I think that we can be ourselves. There's no phoniness, there's no 'I have to watch what I say.' It's not a guarded time. It's just the time to let your hair down and be yourself" (Williams 1996). Connye Brown conveyed a similar experience:

25. Paul Laurence Dunbar, *The Complete Poems of Paul Laurence Dunbar* (Philadelphia: Hakim's Publications, 1980), 71.

26. Thomas W. Ogletree, *Hospitality to the Stranger: Dimensions of Moral Understanding* (Philadelphia: Fortress Press, 1985), 24.

But when I'm with . . . a group (of African American women) I feel like I'm among people who really care for me. I feel like we care for each other and I care for them. And that makes me feel like I'm really a part of things. . . . When I'm with a group, I like it because I can say what I want. I can laugh, which is cathartic. I can really laugh and I think the people see you for yourself. . . . Not you as a person or what you wear or anything, but for you. And that's just really important in that people care for each other. . . . They can be in touch with what's really inside. They can say openly how they feel about anything and be totally honest. (Brown 1996)

"Letting your hair down," i.e., unmasking and disclosing one's true self, is at the heart of the gatherings. Reciprocity of self-disclosure is the hospitality of self for African American women, i.e., "the story sharing uncovers deeply buried pain; brings relief from fruitless acts of denial; awakens joy in the discovery of companions who are one with them in suffering and struggle; provokes rage over the irrationality and arbitrariness of the structures of oppression; heightens a determination to resist to the uttermost any further humiliation and degradation."[27] Donna Jones (1996) described it this way:

They let me know I am not alone. Safe. You know, because these are people who have kind of been there. I don't have to explain why I feel the way I feel about whatever. You kind of complete each other's sentences and that kind of stuff. Someone has been there, done that, hated it or loved it—whatever the "it" is. Or at least known somebody. And we have shared culture so that you don't have to struggle through redefining or making definitions or all that crap, and it's truly a place where you can be yourself, because you are not playing games one way or the other. It's kinda like being with your mom when you were a kid and she knew you better than you knew yourself.

27. Ibid., 5.

The unmasking and speaking of truth, both recognizing infirmities and offering relief from the splintering aspect of a double consciousness, is often accompanied with feelings of discovery, filled with ah-hah moments—sacred moments of wonder and awe. It is a time when the unfolding revelation that "I am not alone" is revealed. Sharon Taylor (1996) said, "When I am with my sisters it is the only time when I am not lonely—it is the only time when I am not afraid." The absence of fear and loneliness and the presence of God at concealed gatherings brings reembodiment in many ways, but especially through laughter.

Concerning Laughter

Laughter is the expression of the awareness of deeply manifested humanness, the expression of the oneness of humanity and God. Many of us only breathe deeply when we laugh heartily. We are our most human selves when we are swaddled in laughter. Scriptures say that the joy of the Lord provides strength. To be African American women immersed in hospitality is to have laughter. In gatherings, African American women often laugh at the oppressor, at oppressive situations, at themselves, and with each other. Laughter is oftentimes healing, renewing, refreshing—in a complex sense, reembodying.

"When the body is mentioned in the New Testament, it is often referred to by the Greek word 'soma,' which usually implies the whole human self: body, emotion, intelligence, will."[28] The spirituality exemplified in concealed gatherings is a spirituality that lives out of the notion of "soma." Through concealed gatherings Christian, African American women remember our very selves, remember to reattach our body (soma) parts, to reconnect with the holy, both divine and

28. Flora Slosson Wuellner, *Prayer and Our Bodies* (Nashville: The Upper Room, 1987), 10.

carnal. The reembodiment provides reconnection with self, sisters, and God. A poem by Walt Whitman says in part:

> ... Womanhood, and all that is a woman, and the man
> that comes from woman,
> The womb, the teats, nipples, breast-milk, tears, laugh-
> ter, weeping, love-looks, love-perturbations and
> risings,
> The voice, articulation, language, whispering, shouting
> aloud....
> The thin red jellies within you or within me, the bones
> and the marrow in the bones;
> The exquisite realization of health;
> O I say these are not the parts and poems of the body
> only, but of the soul,
> O I say now these are the soul![29]

Whitman reminds us that body parts are, indeed, soul parts.

The gatherings enable genuine touch. To feel one's own body while laughing, eating, talking, living, is to receive genuine, healing hospitality. Connye Brown (1996) said, "After (our group) meets I feel better...more like myself again. I noticed it about a year ago, I just feel better in my body when I meet regularly with the group." Sherry Jones (1996) said,

> I can feel the energy of the other women flowing through me during the wild conversations. It is an energy that feels like when my family gathered when I was a child. It is an energy...a magic that let's me know no matter what the world says I am alright.

Laughter plays many roles at the gatherings. Shared laughter brings the harshness of living into perspective and enables the women to see that no problem is insurmountable. Laughter is used to combat the betrayal, humiliation, objectification, and lies of oppressive living. The wickedness of oppression

29. Frances Murphy, ed., *From Walt Whitman: The Complete Poems* (Philadelphia: Rodgers, 1936), 127–28, 134–36.

cannot be underestimated or overstated. When oppression take its toll upon the body, it is toll on the "soma." The daily pressures of living with contradictions, lies, ridicule, and homelessness strain the body with disease and torques the body with ailments of every description. For African American women, enduring the ravages of all the "isms," collectively and individually, means that disembodiment is normative. The "isms" are unmistakably about the body: racism is about the hue of her skin and the texture of her hair; sexism is about her genitalia (or specifically about the presence of a uterus and the absence of a penis); classism is about whose body is put to what kind of labor. High levels of drug and alcohol abuse, spousal battering, stress-related ailments, etc., point to women whose bodies are being tortured and to bodies that are fraying under the torque of the hegemonic experience of dehumanization compounded by the suffering from the despiritization of internalized oppression. The personal experience of disembodiment is often experienced as a loss of "body parts" that are reclaimed through the communal sacraments of these gatherings:

BODY PARTS

some parts I carry with me
in tattered drawstring bags
draped 'cross my shoulders & waist
some in boxes & baskets
hoisted balanced upon my untended head
a few parts are
clutter tucked & squeezed between my thighs
others holstered tightly
at the small of my aching back
still others I have lost track of
left in bygone assaults & insipidness
some few precious parts I have hidden
buried in mother earth
camouflaged in war-torn jungles

concealed in rotting carcasses
no one dare venture there

so many parts are missing faded damaged
it is difficult
to re-member my whole
danceable self

For women who internalize oppression in broken bodies, broken minds, and broken hearts, laughter is a balm for the woundedness. Shared laughter enables women to realize that they are not alone and that there is more to life than burden.

Concealed gatherings invite women to bring their whole selves—selves whose body, emotions, and intelligence are 'buked and scorned. Unmasked women, frothy with laughter, enveloped in the sacramental experience, cannot help but be resilient. The concealed gatherings remind women that God is active in their bodies and spirits, healing, empowering, and blessing.

Making Ethical Decisions

To ask "how" an African American woman provides hospitality is a bit like when Louis Armstrong was asked how he played with such dynamic rhythm and he said, "If you've got it, you don't need to be told how; and if you don't got it, no amount of telling is any good." For an African American woman, hospitality springs from her bricoleur's spirit.

The postmodern, nihilistic age is the soup in which contemporary African American women must make moral decisions. How do we make Christian ethical decisions in a world that is said to be without moral foundations—in a world that clearly does not have the best interest of African American women at heart? One response to this central question is that African American women have cultivated and maintained themselves as Christian bricoleurs. Moral bricolage is a particular process of formulating ethical discussions. William

Greenway, scholar and author, describes the process as follows: "utilizing the critical resources of tradition, history, anthropology and creative art, [African American women] labor to generate as many new 'candidates for truth and falsehood' as possible and to develop a coherent moral language adequate to the needs of the moment."[30] The task of bricolage is to deal with the central ethical issues of our time as free moral agents, i.e., free to creatively use the moral resources as needed by the people of God. The bricoleur's tools are discernment, envisioning, cunning, guts, and ingenuity for the transforming of unholy conditions: "This task involves interpreting the significance of the very real constraints and possibilities—both natural and cultural—that actually affect our lives in light of the belief that the ultimate character of reality is good."[31]

The bricoleurs I see among the women I have studied are steadfast in the knowledge that they trust in a God who sustains, heals, and passionately loves all of life, especially the lives of African American women. Anne Williams (1996) said:

> When I was a child, we did not have many material possessions, but we never knew we were poor. My mother always took the little we had and made a lot—so much so that we had some to give to others.

Ruth Joseph (1996) said:

> As I look back now, I know that my mother was like a magician. She and my aunt made our dresses from leftover material and they cooked delicious foods from practically no groceries. We were well clothed and well fed at all times. They gave us the best they had and then made do with what they had creating the best for us. They expected us to learn to do the same—take a very little and make a whole lot.

30. William Greenway, "Christian Ethics in a Postmodern World? Hauerwas, Stout, and Christian Moral Bricolage," *Koinonia Journal* 6, no. 1 (1994): 10.

31. Lois Malcolm, "The Divine Name and the Task of a Christian Moral Bricolage." *Koinonia Journal* 6, no. 1 (1994): 36.

As African American women struggle in concrete ways with the conflicts and dilemmas between racism, sexism, classism, heterosexism, and the task of raising children, working a job, keeping a home, assisting a husband, friends, and extended family, they "will in multiple concrete instances and in dialogue with . . . peers, put these conflicting goods into creative interplay and formulate justifiable and creative moral judgments which best meet the diverse needs of the moment."[32] This kind of engagement is as a moral bricoleur. African American women provide hospitality by making art from whatever they find around them and by letting what they find tell what to make of it. The bricoleur draws, then, on the mobility and innovation of the artist as well as the available media in order for the art to be created. By choosing to engage the world as a bricoleur, African American women are testifying to the abiding faith necessary to choose life and choose life abundantly.

The stranger-to-stranger hospitality offered at concealed gatherings is one expression of African American women engaging in moral bricolage. Many African American women, as bricoleurs, create homes, birth and raise families, and hold down several simultaneous jobs, not because we are super-women, or even saints, but because we know how to create using available resources to meet the necessary. Nikki Giovanni said about Black women's bricoleur's spirit:

We are the folk who took rotten peaches and made cobblers; we took pieces of leftover cloth and made quilts; we took the entrails of pigs and cleaned them and rinsed them in cold water until the water ran clear then chopped up onions, shredded some red peppers, dropped a few fresh bay leafs and one large whole peeled potato in the pot to let it simmer over the open fire until we returned from the fields so that our families would have a hot meal at the end

32. Greenway, "Christian Ethics in a Postmodern World?" 11–12.

of the day. Everytime something was taken away we took something else and made it work.[33]

In her book *In Search of Our Mothers' Gardens,* Alice Walker describes a quilt that hangs in the Smithsonian Institution in Washington, D.C. The quilt is considered an exquisite piece of artistry, priceless. It depicts the story of the Crucifixion. It follows no American standardized pattern of quilting. Under the displayed quilt is the note card that says it was made by "an anonymous Black woman in Alabama, a hundred years ago." "Anonymous" Black women are bricoleurs. They take what is around them—pieces and bits of cloth, rags, scraps of material, worn clothing, and create, by any standard of beauty, a work of extraordinary art, revealing brilliant, creative imagination as well as deep, deep spirituality.[34] We demonstrate how to artfully prevail in a fractured world. We have created gardens next to shacks and served feasts in tableless dining rooms. We put the work of our souls into what is available, common, and of dire need—our gardens, jobs, children, homes, families, and friends:

GRANNY KNOW HOW

my granny's house is home
doilies sit-up starch-proud
gently displayed
on overstuffed winged-back chairs
garden flowers
splendidly arranged
smile bright in crystal bowls
freshly cooked everythin'
bursts abundantly
from white porcelain stove
her neatly bunned hair

33. Daryl Cumber Dance, *Honey, Hush!* (New York: W. W. Norton, 1998), xx.
34. Alice Walker, *In Search of Our Mothers' Gardens* (San Diego: Harcourt Brace Jovanovich, 1983).

smells clean
as she meets me at her door
hugs my neck
whispering prayer

my granny don't have much
some would say she don't have nothin'
but my granny goes to church
every Sunday
neat as a pin
clean as a whistle
sharp as a tack
her hat sits just tilted to the side
her shoes shine right pretty
her purse in one hand
her bible in the other

granny
raised sixteen children
cut tobacco
cleaned other people's houses
took in wash & sewed

some would say she ought be
in the ground or crazy
or both
by now
but she ain't neither
my granny just simply
know how to...

my granny
know how to...
see bouquets in weeds
braid rags into rugs
&
sew scraps into quilts
she know how to

sing war songs into lullabies
boil roots into medicines
clean hog guts into chittlins'
cook feasts
out of bones of every description
my granny know how to
turn swords into plow shares
pray water into wine
cross rivers without benefit of bridges
she know how to
remake Miss Anne's Goodwill dress
for her own Easter finery
granny know how to
see new dishes in red clay
make new baskets from mud covered straw
imagine new gardens in icy winters
granny know how to
kindle a flickering spark
into a purple flame
find four leaf clovers
in the neighbor's meadow
reshape madness into muse
granny know how to
hear music over
her own head
spin jeopardy & peril into jazz
she know how to
take a little
from here & there
& there & here
create enough for all
& still
have some to spare

my granny just know how to...

▼▲▼ 5 ▼▲▼

Practical Implications for Christian Education

Thus far, I have offered a first-person, reflective, phenomenological essay on African American women and our practice of concealed gatherings for resilience. I want now to discuss some of the meanings I find from this immersion in learning and rediscovery. Consequently, I am concluding this work by bringing biblical connection and meaning into the conversation because of my hope to connect this work to Christian education. I want to know that what I have learned from this inquiry is for use as an educator, particularly its implication for and application in any classroom in which the subject matter is religious education.

I suggest that religious education could gain significant insight for the strengthening of pedagogy from the ways of African American women in concealed gatherings. My key question in conjecturing ramifications for pedagogy is: What do the women who are able to evoke the power of the sacramentality of concealed gatherings around kitchen tables have to offer local pastors, directors of Christian education, superintendents of Sunday schools, etc., for the strengthening of teaching? What will it mean to recognize and harness, in the classrooms of religious education, the power invoked in contexts where the intention is to shape a place for crucial interactions—and to shape those interactions in many different

ways for purpose of resilience and healing? If we are to learn from these women, what will religious educators do differently? In what ways will we think differently? What practices for teaching Christian education in the various settings might we infer from the women, from the concealed gatherings, from stranger-to-stranger hospitality? And, all together, what can we learn from the women, concealed gatherings, and stranger-to-stranger hospitality that might inform, reform, and reshape the classroom experience for both teacher and learner?

Justice and Liberation as Our Bottom Line

In retrospect, it seems rather clear to me that what the women are most interested in, engaged in, and invested in is justice. We are committed to learning resilience, staying resilient, for justice. We want justice for our families, our friends, and ourselves.[1] Our bottom line is justice:

WITHOUT HESITATION

OUR DREAMS—
 honeycomb dripping of golden sweet

OUR DESIRES—
 pulsing, throbbing yammerings for release

OUR HOPES—
 woven tapestries connecting then, now & yet-to-be

WITHOUT HESITATION
 we would would
 would cast them all afloat
 in reed baskets upon river waters
 for—
 JUSTICE.

1. See Patricia Hill Collins, *Black Feminist Thought: Knowledge, Consciousness and the Politics of Empowerment* (New York: Routledge, Chapman and Hall, 1990).

When society and the church choose to deny justice, we refuse to be stymied. As my friend Michele told me, "not coping is not an option for Black women—we will find a way."[2] Stranger-to-stranger hospitality for African American women by African American women, being inherently political in a world that provides limited safe public space, is aimed at the agenda of justice for oppressed people. "Living as we do in a white-supremacist capitalist patriarchal context that can best exploit us when we lack a firm grounding in self and identity (knowledge of who we are and where we have come from), choosing 'wellness' is an act of political resistance."[3] To choose compliance with oppressive systems would be to choose ease, albeit, ease unto death.[4]

Choice and Choosing

The choosing of wellness, which for us requires the choosing of resilience, is the choosing to fight back, to resist oppression of all kinds, and to reshape teaching and learning for something other than the status quo. Exercising choice, in and of itself, is an act of freedom. When African American women choose to gather in hen parties, we are choosing a subversive activity of resistance. In the stranger-to-stranger hospitality of concealed gathering, African American women create an enabling power dynamic for resisting, for fighting back, for pressing on.

2. Michele Case is a lifelong friend and has supported me throughout this journey.

3. bell hooks, *Sisters of the Yam* (Boston: South End Press, 1993), 14.

4. Kelly Brown Douglas, *The Black Christ* (Maryknoll, N.Y.: Orbis Books, 1994) writes in her endnotes (130): "In previous writings I have labeled this (phenomenon) a 'spirituality of survival.' Informed by what Patricia Hill Collins describes as a 'culture of resistance,' which Black women have nurtured, I now describe this as a 'spirituality of resistance.' The term 'resistance' implies more than just finding a way to exist, but it also suggests fighting back against that which is oppressive. Resistance suggests a more active image than is perhaps suggested by the term survival." I am adding to this conversation the notion that we are talking about, witnessing, and participating in a spirituality and pedagogy of resilience.

The power dynamic of an African American woman's concealed gatherings with her sisters is ultimately a powerful collaboration between herself and her sisters. I am referring to "power" as Ntozake Shange's "Lady in Purple" defines it: "A layin' on of hands; the holiness of myself released."[5] Concealed gatherings are fundamentally political because they are grounded in the antiracist and antisexist struggle. They are counterhegemonic acts. "I am not old enough to have marched on Selma or on Washington for that matter," said Cheryl McFadden (1996), " ... but, when I sit with my sisters laughing and teaching and just messing around I know that this must have been like that ... people planning for a better way of living for everybody. We talk about current events all the time. We share opinions and argue about Clarence Thomas and O. J. ... it's not a big revolution, but it is a revolution." These gatherings of African American women teach resistance to oppression and annihilation. The gatherings also help to alleviate the wounds of internalized oppression:

> My father would always tell us "niggers ain't shit." I'd heard this so long that I believed it. At the group meetings I would hear well-educated women laughing and whooping and acting-a-fool, but they would be laughing at all the injustice and pettiness and lies. They wouldn't be laughing at each other or gossiping or nothing like that. It was deep. (Andrews 1996)

Anne Williams (1996) said:

> I love gathering with my group. I like most of all the stimulating conversations we have about national and world politics. The talks help me to think through all the stuff of living in the '90s and all the difficulty of trying to be a Black woman in the '90s.

5. Ntozake Shange, *for colored girls who have considered suicide when the rainbow is enuf* (New York: Macmillan, 1977), 66.

Public education, since the dismantling of segregation, has been duped, under the guise of desegregation, away from the political, educational agenda of resistance. Too many Black churches are intoxicated by the post–civil rights malaise and entombed into a misguided, sanctimonious capitalistic funk. African American women in concealed gatherings, like the delicacy of a whisper, have not abandoned the agenda of justice and liberation. Learning from these women may simply mean putting the agenda of justice back in our churches and seminary classrooms. I am suggesting that the domestication (the taming, the acculturation of a post-slavery mentality of passivity, steeped in capitalistic values that demand compliance with our own oppression) of our churches and our church education must cease. Classrooms, like concealed gatherings, must take on the agenda of liberation in explicit ways. The educational agenda must reflect the reality of oppression, and equip students, of all races and each gender, for the battle of liberation.[6]

By weaving the political agenda of liberation into the classroom, I suspect there would be a major shift in the way people approach the thinking and doing of Christian education. The clues and avenues into thinking about this transformation for a liberative agenda in the classroom can be found in the lived experience of many African American women who struggle to form and maintain our own resilience and the resilience of the people. The entree is, I am suggesting in typical African American church style, the biblical story. Katie Cannon writes:

> In essence, the Bible is the highest source of authority for most Black women. In its pages, Black women have learned how to refute the stereotypes that depict Black people as minstrels or vindictive militants, mere ciphers who react only to omnipresent racial oppression. Knowing the Jesus

6. See Anne Wimberly, *Soul Stories* (Nashville: Abingdon Press, 1994) for a fascinating look at "A View of Liberation from the Inside," 22–26, eight dimensions of liberation.

stories of the New Testament helps Black women be aware of the bad housing, overworked mothers, underworked fathers, functional illiteracy, and malnutrition that continue to prevail in the Black community. However, as God fearing women they maintain that Black life is more than defensive reactions to oppressive circumstances of anguish and desperation. Black life is the rich, colorful creativity that emerged and reemerges in the Black quest for human dignity. Jesus provides the necessary soul for liberation.[7]

Hospitality in the Bible

If my intuition is accurate—and the bottom-line lesson from these Christian, African American women is justice and liberation, especially for Christian education classrooms—then Bible study and Bible story are points of departure and points of destination for the learners and teachers of Christian education.[8] Old and New Testament stories remind us of the seriousness of welcoming strangers and providing hospitality to strangers. The stories tell us that it is oftentimes the guest who gifts the host. "When Abraham received three strangers at Mamre and offered them water, bread and a fine tender calf, they revealed themselves to him as the Lord announcing that Sarah his wife would give birth to a son (Genesis 18:1–15). When the widow of Zarephath offered food and shelter to Elijah, he revealed himself as a man of God offering her an abundance of oil and meal and raising her son from the dead (1 Kings 17:9–24)."[9]

For many Christian, African American women, the resurrected Jesus (as messiah, lover, brother, friend, etc.) is the key theological entry point for making meaning in the midst of oppression and misery, for having confidence in the atti-

7. Katie Cannon, *Katie's Canon* (New York: Continuum, 1995), 56.

8. A favorite African adage says that, "wherever you start will be where you end up." To start with the story of Good News is to end with the story of Good News.

9. Cannon, *Katie's Canon*, 66.

tude of hospitality.[10] The resurrected Jesus of the Emmaus story is the messiah both then and now. The Emmaus story is paradigmatic of the kind of hospitality I witnessed and participated in along with the Literary Group. I have talked about stranger-to-stranger hospitality as I saw it and participated in it with the Literary Group. Now, I want to look at this kind of hospitality as it is appears in the biblical story of Luke 24:13–35. It is the story of two friends who invited a stranger who had joined them on the road while walking to Emmaus to stay with them for the night. He made himself known in the breaking of bread as their Lord and Savior, Jesus.

Strangers on the Emmaus Road

Chapter 24 of the Gospel of Luke offers the story of Jesus after the crucifixion, on the day of the resurrection. The apostles had been told of the empty tomb and the encounter with angels by Mary Magdalene, Joanna, Mary the mother of James, and the other women. The apostles did not believe the fantastic story that the women told, but Peter got up and ran to the tomb to see for himself. Peter saw that Jesus' body was no longer in the grave, and the text says that he went home, amazed at what had happened.

We know that the story of the road to Emmaus occurs on the day of the resurrection. But, for the two friends, Cleopas and an unnamed friend, it is not the joyous day to celebrate life that sprang from death. It is, instead, a day of confusion and distorted reality. Cleopas and the friend had journeyed with Jesus—learning, witnessing, enjoying, and being challenged by his company and teaching. The two, no doubt, watched as Jesus was tried, convicted, crucified, and buried.

10. See such texts as: Jacquelyn Grant, *White Women's Christ and Black Women's Jesus: Feminist Christology and Womanist Response* (Atlanta: Scholars Press, 1989); Kelly Brown Douglas, *The Black Christ* (Maryknoll, N.Y.: Orbis Books, 1994); James Cone, *A Black Theology of Liberation* (Philadelphia: Lippincott Press, 1970), 2nd ed. (Maryknoll, N.Y.: Orbis Books, 1986).

On this day, Cleopas and his friend were in deep mourning for their beloved friend Jesus.

Many of us can recall the confusion of burying a loved one. Even when we watch the living and dying of the person, the days after the death bring an eerie, peculiar reality. Before this day, it seemed unimaginable to be without the loved one, yet on this day, the person is gone, not to return. The days after burying a loved one cause us to put on our best face, hoping the world will not notice new cracks in our heretofore well-sculpted mask. We dress slowly and carefully, selecting clothing that will costume our hurt. We place our feet gingerly on the ground, unsure if the ground will support and sustain us or split open and swallow us whole. The days after a loved one is buried are days of existential muddle.[11] They are days when that which was familiar is unfamiliar, that which was routine is unusual, that which was intimate is strange. People who grieve become like strangers in their own land, strangers in their own bodies, strangers in their own experience.

The two men who walked the seven-mile journey from Jerusalem to Emmaus were no doubt feeling grief stricken, feeling as strangers. Not only had their friend Jesus been crucified and buried, but now there were reports and speculation that Jesus had risen from the dead. The two friends walked to Emmaus to leave Jerusalem, to clear their heads, and to give some distance to all the events of the passion.

The Gospel of Luke says that while the two friends walked down the road, the resurrected Jesus joined in the walk. Jesus said to them, "What are you discussing with each other while you walk along?" (Luke 24:17). The one named Cleopas said to Jesus, not recognizing him, "Are you the only stranger in Jerusalem who does not know the things that have taken place

11. I am indebted to Dr. Katie Cannon for this perspective of the Emmaus road story. Dr. Cannon preached a sermon entitled "Emmaus Road" in the spring of 1998 at a church in Chestnut Hill, Philadelphia. Though she did not talk specifically about stranger-to-stranger hospitality, I could hear this theme woven throughout her sermon.

there in these days?" (Luke 24:18). In their grief, even the one who was nearest and dearest to them is called a stranger, recognized only as a stranger, addressed as a stranger. On the walk to Emmaus, all are strangers.

The men went on to explain to Jesus, the stranger, that their friend who they had hoped would redeem Israel was condemned and put to death and how the women of the group had seen visions of angels who had said that Jesus was alive. Jesus chided the men and called them foolish and slow of heart. Jesus walked and talked with them, explaining all the prophets and interpreting for them the things about himself in all the scriptures. As they approached Emmaus, the men asked Jesus to stay with them.

Jesus agreed to stay, and the three of them sat at a table together, preparing to share a meal. Jesus took bread, blessed and broke it, and gave it to them. As Jesus did this, the friends recognized Jesus; then Jesus vanished from their sight.

For African American women, in the torque of oppression, each and every day is a day on the Emmaus road. For African American women, the beloved one is our own selves mutilated by racism and sexism. African American women, on the walk to Emmaus, do not recognize the love around them due to the grief, confusion, anxiety, and distortion of ourselves and of our people. When hospitality is offered, stranger-to-stranger hospitality, we are able to experience the risen Christ in our own midst.

Encounters with Jesus after the resurrection were not then, and are not now, glamorous or dazzling. Few of us will be struck blind like Saul, few will have an angel announce a coming birth, few will be visited by kings from Asia bearing gifts or be paraded by smelly shepherds. Few will see the divine dove descend or hear a heavenly voice proclaim the presence of majesty as was done at Jesus' baptism. Post-resurrection encounters for African American women are subtle, ordinary moments experienced while living faithful lives. Post-resurrection encounters are just as liable to hap-

pen in classrooms between pastors, teachers, and disciples as they are on the road to Emmaus.

These moments, manifestations of Holy Communion, are ordinary moments turned into extraordinary encounters. Meeting Jesus, then and now, occurs when ordinary strangers, people estranged from themselves and each other, dare to invite each other to the table. I want to briefly consider aspects of this Emmaus story that illumine the conversation concerning stranger-to-stranger hospitality.

The Aesthetic of Storytelling and the Breaking of Bread

A bold theme in Womanist work has been the notion of the aesthetic. My use of poetry and poetic prose throughout this book is my rendering of the aesthetic I see and sense in these women. Intellectually and intuitively I know that the aesthetic is a primary force in and for the resilience of many African American women. Our resilience is honed when mystery is conjured and the aesthetic enables the conjuring of mystery. We know that the stranger-to-stranger encounter of the Emmaus account ends with the recognition of the beloved Jesus. We know that the Literary Group has gathered for nearly five years with no plans to cease our gatherings and with reports of overwhelming joy in gathering. The question must be asked: What is the aesthetic that breaks into the moment of hospitality that transforms and transcends the stranger-to-stranger relationship? I am suggesting that it is the aesthetic of storytelling and of the breaking of bread.

In the Emmaus story, Jesus after chiding his friends, tells familiar stories about himself, about the prophets, about living faithful lives. The friends, while walking and talking with the stranger Jesus, tell their story of grief and woe. The element of storytelling creates the aesthetic location for the strangers to find common ground. Each time the Dear Sisters' Literary Group gathers, we gather around a story. The group, though

informal with few rules or expectations, voiced early in our collective life that we would read stories written by African American women about African American women. At each meeting, we update one another about ourselves and our families through storytelling. It is in the aesthetic, particularly story, that Jesus and the friends, and the Dear Sisters' Literary Group create a context through storytelling where truth might be spoken, where truth might enter in, and where truth might be revealed.[12]

In the Emmaus account, Jesus walked with the strangers, telling and listening to stories. The revelation came for the men when Jesus took the bread, blessed and broke it, and gave it to them. The story and the breaking of bread allowed recognition of the divine in their midst. The Literary Group started without a shared meal. We originally said we would not break bread together. This lasted only a short while. Each meeting, like the Emmaus account, is now a time of storytelling that culminates in the sharing of bread and a blessing of one another. The incarnate mystery of the gospel is revealed, released, and remembered with the sharing of the most common—in this case, the sharing of story and bread.

In the exchange where estranged people share—something happens when one person becomes the host willing to share (although not at home) and one person becomes the guest willing to risk. In being willing to share and in being willing to risk, both gestures of faith, the relationship becomes possible. In sharing and risking, both guest and host allow each other to step across the threshold into Mystery. Mystery gives way to familiarity. Once in the presence of Mystery, all are known, no longer estranged. In the presence of God, invoked by gathered strangers, we are our most connected, familial, human selves. Mystery also gives way to surprise. As strangers on the Emmaus road and at Literary Group meet-

12. See Parker Palmer, *To Know As We Are Known* (New York: HarperCollins, 1993). See especially chapters 5 and 6.

ings, no one knows which one among the group is or is to become the Incarnate One. Jesus may be one, both, or all of us. It is more likely to wonder "which ones" are the presence of Jesus than to wonder "which one" is the presence of Jesus. At the Literary Group gatherings, the women who become the priest become the incarnate presence of holiness that is transformative for all. The priest may or may not be the woman whose home we are visiting. The role of host and guest moves around the group. In this movement something happens that binds the women of the group together. We cannot define what happens, but we can witness it and engage it. Women can participate in it. It happens in the interplay between stranger and stranger, between sharer and risk taker, between guest and host. It is Mystery, Divine encounter, grace poured out.

Most importantly for this work, I now believe that sacramental encounters can break forth in Sunday school classrooms, Bible studies, cell groups, house churches, covenant groups, and so on. The eucharistic mystery is available to us in theological classrooms when we expect to invoke mystery and look to one another as the possible priest of the unfolding incarnation, the progressive revelation. In the classroom, teacher or student or pastor may be priest, incarnating Jesus, creating a threshold for Mystery to break through. The invocation, however, takes sharing and risking by learner and teacher.

Christian education must move toward practices that bring the sharing of story and the breaking of bread into the classroom if we are to invoke sacramental encounters for and with our learners. Classrooms can be described as stranger-to-stranger encounters with teachers, feeling as strangers in their own classrooms unable to host, and students unwilling and unable to be vulnerable guests. The classroom, then, has the potential for the stranger-to-stranger encounter to become a threshold for Mystery, in the Christian sense, because of the potential incarnate presence of the divine.

In religious education, the aesthetic is taken seriously as the subject of scholarly conversation. Christian educators such as Maria Harris have kept the agenda of the aesthetic in the forefront of scholarly dialogue.[13] I believe that the aesthetic must also be the means of scholarly conversation.[14] To teach with the aesthetic as means of the conversation as well as the subject of the conversation is to teach as Jesus taught.

Principles and Practices of Womanist Pedagogy

Womanist pedagogy is emerging and being codified by such scholars as Cheryl J. Sanders, Patricia Hill Collins, Katie Cannon, Kelly Brown Douglas, and JoAnne Marie Terrell. "In her discussion of the contours of an Afrocentric feminist episte- mology, Patricia Hill Collins cites four elements: (1) concrete experience as a criterion of meaning, (2) the use of dialogue in assessing knowledge claims, (3) the ethic of caring, and (4) the ethic of personal accountability."[15] JoAnne Marie Ter- rell reminds us that, "Womanist epistemology ... affirms the use of personal narrative in order to relate black women's history and religious experience."[16] Katie Cannon organizes Womanist pedagogy around three major principles: histori- cal ethos, embodied pathos, and communal logos and says, " ... these three concepts help us to live more faithfully the radicality of the gospel."[17] Historical ethos, for Cannon, is

13. See Maria Harris, *Teaching and Religious Imagination* (San Francisco: Harper- SanFrancisco, 1987).

14. The work of Howard Gardner as conveyed by Thomas Armstrong, *Mul- tiple Intelligences* (Alexandria, Va.: Association of Supervision and Curriculum Development, 1994) is very helpful in this matter.

15. Cheryl J. Sander, *Living the Intersection* (Minneapolis: Fortress Press, 1995), 164.

16. JoAnne Marie Terrell, *Power in the Blood?* (Maryknoll, N.Y.: Orbis Books, 1998), 8.

17. Katie Cannon, "Translating Womanism into Pedagogical Praxis" (The Loy H. Witherspoon Lecture in Religious Studies, University of North Carolina at Charlotte, April 2, 1977), 3.

teaching from and with Black consciousness or from and with an Afrocentric perspective. By "embodied pathos" she means "that requirements for the course are designed to facilitate students in teaching themselves what they need to know."[18] And communal logos has to do with creating a classroom environment where conversation freely flows from teacher to student; from student to teacher; and from student to student. In the discussions, "questions and answers are continually reformulated."[19]

In joining my voice with these sister-scholars, I am suggesting that the seminary classroom that is relevant to the liberative motif springs from, supports, and defends the lived experience of African American women while at the same time it "challenges conventional and outmoded dominant religious resources so as to deconstruct those ideologies which lead us into complicity with our own oppression." Sunday School classrooms must endeavor to become sacramental classrooms.[20]

The work of these sister-scholars is helpful in theorizing concerning Womanist pedagogy, but our nature is to always ask "how?" How does one charged with the responsibility of sacramental teaching go about employing Womanist principles in the seminary setting? Building specifically upon insights from the Dear Sisters' Literary Group, Dr. Cannon's work, and with the Emmaus story as the biblical framework, I want to talk briefly about practices for a Womanist pedagogy to teach with hospitality as the atmosphere and catalyst for learning. When we are strangers (in this case, ourselves as teachers) providing hospitality for strangers (in this case, our students), what do we do to invoke the power of mystery within the classroom setting? As teachers, what practices can we hone that will provide hospitality for our learners?

18. Ibid., 7.
19. Ibid., 11.
20. Ibid., 3.

Practices for Historical Ethos

"Historical Ethos is a liberating term applied to politically and socially aware members of the African American intelligentsia who embrace the spirit, standards and ideals that characterize our rich educational heritage. In other words, 'historical ethos' is a conventional device used to critique the cultural context and the political climate that prevail in formally structured learning environments."[21] Keeping, honoring, safeguarding, right-telling, and proclaiming African American heritage (in its simplicity and complexity) suggests specific tasks for the seminary classroom.

Practice #1: Tell the Story (The Aesthetic Engaged)

The power of story to teach and transform cannot be overemphasized. The dynamic possibilities of teaching are revealed in the practice of storytelling. Over and over the women in the study said they were grateful for hearing and telling stories at the Literary Group meetings because the stories gave them new perspectives and reminded them who and whose they were. In the Emmaus story, the men shared stories as they walked and were comforted in their grief. Kelly Brown Douglas says that storytelling allows students, Black and White, male and female, to discover that they are not alone in their struggle for liberation. She says that stories give us exemplars and encourage us toward actions of resistance and justice.[22]

I have learned, thus far, to incorporate story and storytelling into my classroom: (a) by telling stories as examples for concepts, to illumine obscure notions or abstract ideas; (b) by assigning novels, poetry, autobiographies, and dramas as texts for classes; (c) by encouraging students to demonstrate their proficiency for a class by writing poetry, autobiographies, dra-

21. Ibid., 4.
22. See Cheryl J. Sanders, ed., *Living the Intersection* (Minneapolis: Fortress Press, 1995), chap. 8.

mas, sermons, skits, short fictional and nonfictional stories, songs, and hymns; and (d) by inviting topical experts into my classroom—not to lecture, but to tell their life stories and stories of triumph.

Practice #2: Pray for Students and Self

Taking seriously the notion that the Incarnate One will appear in the classroom has brought me to a disciplined, daily prayer life. The Emmaus story and the women in the Literary Group point to prayer as a tool for inviting the Mystery. I pray before class for each student. I structure during class a devotional time led by learners. I pray during the week for myself and my learners. An intentional discipline of prayer is a necessity for sacramental teaching when offering stranger-to-stranger hospitality.

Practice #3: Assume Nothing

As a teacher with the explicit agenda of evoking Mystery into my classroom for liberative praxis, I have learned that I cannot assume anything. I cannot assume that: racial ethnic people are articulate about issues of culture, even their own culture; women are knowledgeable about feminism or Womanism; men have dealt with their sexism; Whites have dealt with their racism; oppressed people do not discriminate or have healed from their internalized oppression. I cannot assume that my students know the biblical story, nor can I assume that an emancipatory education is their own agenda. I have learned that, as much as possible, I must be explicit in all things.

Part of being explicit is developing a vocabulary in the classroom that my students can understand and use. The language of the academy tends to be particular, stiff, and stilted. I work at a communication style that is invitational and a vocabulary that is multilingual, multidisciplinary, and multicultural. I have seen the master teacher Dr. Maria Harris

achieve this extraordinary feat. She uses a metaphorical language filled with symbols, oral vignettes, and stories to convey one concept many, many ways and many, many times. She painstakingly links stories of the ancient with contemporary time, then challenges her students to make ethical decisions based on their own new insights. She works at maintaining this extraordinary ability by taking seriously that she is a life-long learner who must constantly read, constantly explore, and constantly experience anew what she is attempting to teach.

Practices for Embodied Pathos

Dr. Cannon's second principle is "Embodied Pathos." "Linking 'historical ethos' with 'embodied pathos' centralizes personal experience in teaching for justice-making transformation. . . . In addition to past history, we must unmask the truth of our life circumstances as identifiable referents."[23] This second principle points to the intentionality necessary for the shaping of curriculum and designing lesson plans with an emancipatory agenda that has as its cornerstone the notion of hospitality.

Practice #4: Curriculum Design and Lesson Planning

One of the great challenges for me is creating a plan for my classes that will embody the sacramental nature of teaching/learning that I am trying to invoke. The lesson is like the meal and the curriculum is the recipes. Like a successful dinner party, one of the keys to effective Womanist pedagogy is intentionality. I engage in a three-phase process.

In Phase 1, the plan starts in my head and stays there incubating for a long time. I look at plans from past classes, attempting to see the voices they brought into dialogue and the methods I employed. I consider and read books for the

23. Cannon, "Translating Womanism into Pedagogical Praxis," 7.

class by asking myself, "Who do I want my students to encounter and be influenced by?" I consider learning activities that have been effective in the past as well as assignments and methods I want to try for the first time. I consider the students who are likely to attend my class, the time of day the class will be taught, and the season of the year.

I identify the skills necessary for application of the theories in the class in the local church and wider world and think of ways to have the students practice those skills. I take into consideration my own current interests and projects and try to think of ways to bring my freshest work into the classroom. I look for upcoming community events, conferences, and potential field trips that might be added to the menu in the class. I consider and reread the "traditional" scholars of the particular discipline, then intentionally look for the work and voices of women and racial-ethnic peoples to add, to substitute, and to counterbalance. I consider experiential methods of teaching that engage the many intelligences that the students bring to the classroom. I try to think of teaching methods and assignments that will be fun, challenging to both the left- and right-brain thinkers. And, finally, in the preliminary stages of the class design, I pray about the work that I am attempting to craft. In this stage of design, I am like a hostess preparing for a dinner party. My utmost concern is for the comfort and enjoyment of my guests/learners. I want to make sure my learners have what they need to fully participate in the class, to fully engage in pedagogy.

In phase two, I begin to actually write the plan down. Using an established format, I write in all the assignments I am considering, all the texts I am considering, and the daily class format I am considering. I try to balance all these components based on my past experience and based upon those things I want to experiment with that year. I try new concepts and methods each year. After a time of balancing, decision making, keeping, and culling, I write out a rough draft of the plan for the entire class, usually several sessions, about ten

to fifteen pages in length. I edit the plan down, then begin a process of preparing for each teaching session.

In phase three, I present my students with the plan on the first day of the class. I feel like a baker unveiling a wedding cake to the nervous bride. I establish a routine of making diary entries after each class meeting. The course then unfolds in the following weeks with the discussions going in directions that I planned for, and more excitingly, going in directions I never imagined and for which I have not planned, but for which my preparations have readied me. I tweak and torque the learning activities based upon my students' requests throughout the year. I ask the students to write an evaluation of the class. By the last day of class, I feel like a host left with a messy kitchen after a sumptuous meal. I take the days immediately following the end of the class to review my journal entries that I have made throughout the year concerning each class session. I review the student evaluations. With the experience and evaluations of the class I have just completed, my mind eagerly turns to anticipating the next class and designing ways to improve my teaching.

Practices for Communal Logos

Dr. Cannon says that the third principle, "Communal Logos," "distinguishes the womanist classroom as a place where dialectic-dialogic conversations can happen."[24] Key features, she states, in the Womanist classroom are reciprocity, interactivity, and a variety of pedagogical methodology. Together, the learners and teacher attempt to move from rigid pedagogy into a liberative praxis by immersing themselves in the cognitive and bodily dissonance bubbled up by the course's content and by classroom interaction. Facing the challenge of dissonance, both learner and teacher become self-aware and

24. Ibid., 11.

deliberate participants in liberation, moving ever toward con-scientization. Dr. Cannon says, "I too have learned to come to class, not thinking of a territory to be covered but with a compass so as to determine the metalogical direction among a community of critically conscious ethicists."[25]

The women in the Literary Group gatherings share this principle of Communal Logos. The lively discussions are rich with teaching and telling that move participants to deeper thinking and understanding. The taking-of-turns in hosting the gatherings is a shared reciprocity that respects each member and honors each visited home, and further serves as a gesture of expectation for a deeper participation in the life of the group. The ritualistic meal sharing at each gathering moves the sisters past individualism and into an experience of community, church.

Practice #5: Active Listening

The skill of listening is a critical tool that is alluded to in Dr. Cannon's work as well as in the work of the concealed gathering. For a teacher to encourage and to risk dialogue is to risk the active posture of listening. I have found that decreasing lecture time and increasing time structured for dialogue helps to facilitate this practice. I have, in several classes, required my learners to come to class with pre-formulated questions for the dialogue. This approach demonstrates to the students that they are (a) responsible, in part, for the dialogue, and not spectators of a lecture; and (b) powerful and smart enough to ask valuable questions of the teacher, the text, the world-at-large, and the powers that be. I work at active listening in my classroom. My active listening is phys-ical listening as well as intuitive listening. Discernment is a tool in my classroom. A clue that a class is going well is when I spend as much or more time listening rather than

25. Ibid., 13.

talking (which usually happens by the third or fourth class session).

Practice #6: Expect Emotions

When you dare to enter into lively dialogue, risk asking critical questions, and dare to think and rethink the status quo, emotions inevitably flare. As classroom teachers, we must not fear our own or our students' emotions. We must allow our students to feel discomfort, anger, joy, sorrow—the range of human experience. We must give permission for emotions to enter into the conversation. At the same time, we must keep in mind and keep before the students that we are all adults and that adult emotions do not rule adult behaviors. Encouraging emotions in the classroom does not mean encouraging volatility or rudeness. There are appropriate and inappropriate ways to express vivid emotions, particularly in the classroom setting. At the same time, the classroom is an invaluable place where emphasis can be placed upon individual expressiveness and the capacity for compassion and empathy.[26] Mistakes of behavior will happen, and when they do we must be willing to say "I'm sorry" and be willing to respond "You are forgiven." Emotions should not eclipse the intellect, nor should the intellect eclipse the emotions.

Practice #7: Being Responsive

Dr. Cannon specifically mentions the characteristic of reciprocity in the classroom. For me, part of reciprocity is responsiveness. I return all phone calls. I learn the students' names quickly and call them by name when I see them at church and around town. I try to be consistent with my students. Each week I come to class with an upbeat attitude. I am well prepared and try to project an attitude of expectation for their learning and achievement. Each of these

26. See Patricia Hill Collins, "The Social Construction of Black Feminist Thought," *Signs* 14 (summer 1989).

gestures is an attempt to be "present" with my students as more than a "talking head" in the classroom. The responsiveness is an attempt to honor them and their struggle toward conscientization.

Practice #8: Claim Your Own Personhood

The teacher is never gender neutral, never racially neutral, never culturally neutral, never class neutral, never neutral in sexual orientation. I go into any classroom with all of who I am. I try to bring my whole self into the classroom: I am Black, I am female, I am middle-class, I am American, I am straight. I do not leave these aspects of myself at the door, but I need to be aware that they give me a particular worldview that helps to set the emancipatory agenda in my classroom. In turn, I ask my students to bring their whole selves into the classroom. When they speak, I want them to be and become aware of their own voices as men, women, Black, White, Asian, etc. I tell personal stories to illuminate concepts. I often ask students to write an educational/religious autobiography as a way of encouraging them to move toward sociopolitical and spiritual awarenesses. Recently, a student fearful of writing his autobiography asked during class if I would give them a copy of one of my autobiographical writings. He felt his writing would make him too vulnerable and that speaking his truth, even a little bit, would compromise him. He said the assignment made him unsafe. I agreed to give the class a copy of my autobiography and did so. This gesture comforted the student and he was able then to write his autobiography with less fear. Many of my pastoral colleagues disagreed with me and said they might have passed out a copy of their resume, but they would never have disclosed themselves in such an open way as to disclose their own story. I believe responsiveness and reciprocity means that we share and risk as much as we ask our students to risk. Or perhaps it means that we share and risk more.

Practice #9: Create Ritual in the Classroom

Completing a course, as teacher or learner, is an accomplishment to be celebrated. I have begun the practice of ritualizing the last class meeting of each course. I create a modest altar in the classroom and we gather in an expression of worship. We sing familiar songs of triumph, we retell stories of personal struggle and triumph, we pray together, we read scripture. I offer words of gratitude for hard work and new insights and invite the learners to share anything they need to share to feel complete in this journey. We then share a meal together. Sometimes, it is a meal I have prepared. Sometimes it is potluck. Sometimes it is the local, fast-food chicken. All the same, the sharing of this meal brings depth, meaning, and closure to our shared journey. The eucharistic meal is a celebration of our work.

Food for Thought

In the midst of the stranger-to-stranger interaction is the interdependence of food, undergirded by the vocabulary that describes the community of faith rooted in the Bible. The aesthetics of food and the aesthetics of biblical language provide imagery and sounds of the meal, the communion, that carries meaning. After having just made a case for the liberative power of sacramentality, however, I have to recognize that the Bible may no longer be functioning this way due to a shift in mealtime and habits of families and due to the change in the nature, role, and function of the "nuclear" family. The Bible is no longer taught in many churches or "caught" in the environs of the home and community. Many people no longer eat family meals around the table beginning with a shared blessing. Fast food, fragmented families, low and no attendance at Sunday school, no home Bible study, longer work hours for adults, unsupervised children and youth . . . all contribute to a new and different way of meaning making. Perhaps, with the

current generation, we have lost the aesthetic of food, the nurturing that comes in shared dining, and the biblical tradition that is rooted and grounded in shared communion. Perhaps this loss most calls for teaching that is in many senses more communal.

Epilogue

Many Christian, African American women, by gathering in concealment, have intuitively devised, kindled, and rekindled ritualized behavior that honors and illumines the sacramentality of living. Many African American women have nurtured a "sacramental imagination."[1] "All reality is imagined as capable of being enfleshed by God, analogous of the way God is enfleshed in Jesus Christ."[2] When African American women engage the world, we do so from a post-resurrection vantage point. We could not face this life if our worldview were only from the foot of the cross. We walk, not just to Calvary, but on the Emmaus road. We walk with the assurance that deep intimacy has revealed and continues to reveal our beloved. In the revelation is justice. Rituals, when they capture our sacramental imaginations, illumine and hearken us to the very real grace of justice.

Wholehearted participation in the teaching labors of local churches would be to work at the brewing and steeping of the realm of God. As sacred activity, education is "the sharing of the intellectual and spiritual growth of both teacher and learner."[3] Education would be an event of the body, emotion, intellect, and will striving for an individual's potential and calling for a communal matrix of support. The communal matrix of support would be about intimacy and sensuousness—an intimacy that grows out of connectedness

1. Jack L. Seymour, Robert T. O'Gorman, and Charles R. Foster, *The Church in the Education of the Public* (Nashville: Abingdon, 1984), 123.
2. Ibid., 139.
3. bell hooks, *Teaching to Transgress* (New York: Routledge, 1994), 13.

where people are accountable and where accountability compels persons toward creativity and innovation for justice. This spiritual education as "loving connections" is where the connections foster community on the deepest levels of intimacy. This kind of education in community rehearses the question, *How should I live in the world? How should we live in the world? How would God have us live in the world?* The rehearsal of this question would be embraced with body, mind, and spirit not looking for the "right" answer, but seeking to experience all the responses that would bring freedom, healing, empowerment, and life. Education would repeatedly ask the question of the teacher and learner, *How is it with your soul?* understanding that all of us are one and that all life affects all other life. Christian education must be acknowledged as a ritualized, sacramental activity if justice and liberation are to return as an agenda for our churches.

If I were to reimagine liberative praxis education in local churches, I would make all classrooms kitchens. I would go to the best cooks of the faculty and local churches and photograph their kitchens. I would re-create those spaces within the seminary down to the last, precious detail. If funds were limited, I would simply convene educational gatherings in the kitchens of those persons who are known throughout the community as hospitable persons. Or, I would gather persons around fireplaces in the winter time for critical thinking and lively dialogue. I would construct huge hearths in classrooms. In front of a blazing fire, we would retell the stories of triumph and dignity and debate the ethical ramifications of our actions. We would decide on actions and strategies for change, then fulfill those strategies, returning to the hearth to report and reflect upon the changes we had brought to bear on the world. We would listen to each other listening for the truth of the people of God.

Or, I would gather people on front porches, in rocking chairs. I would give each learner a needle and thread and cloth. We would sit together talking and discussing, critically

thinking and rethinking, and by the end of these meetings we would have quilted into the world a new blanket for a needy child. I would ask that time be allotted during each class gathering for lively prayer and raucous laughter. The central questions of exploration would be as mentioned: *How should I live in the world? How should we live in the world? How would God have us to live in the world? How is it with my soul, your soul, our souls together?* Some gatherings would be of mixed genders, some exclusive to one or the other. All the gatherings would be cross-generational.

We would explore taboo subjects, become active in civic projects, and travel. Persons charged with the opportunity of gathering others would be steeped in firsthand knowledge as gracious hosts and revered as prominent people in the community. It would not really matter the task that we gathered around—dining, storytelling, quilting. What would matter is that the experience would be about intimacy, nurture, and care, calling all to engage the world and resist oppression. The gatherings would be full-blooded, intimate, woven together with the senses to experience awe, delight, truth, and hope. The encounters would be a continuing remembrance and engagement of the life of God in the world.[4]

My hope is that a Womanist pedagogy will radically change theological education, so much so that our students will radically change the church. Oh, that it would be so!

I am pleased to report that, as of spring 2001, the Dear Sisters' Literary Group is still meeting. We still gather monthly in each other's homes. We talk about the book of the month. We eat from our potluck menu. But most important, we banter, dialogue, discuss, heal, and mend each other. Still, in the time of this concealed gathering, Jesus is in our midst.

4. Don E. Saliers, *Worship Come to Its Senses* (Nashville: Abingdon, 1996), 38.

Index